751.454 Mar Martin i Roig, Gabriel, Painting Landscapes

> ✓ W9-AJP-034 12.99 ocm68710054

WITHDRAWN

© Copyright 2006 of the English-language edition for the United States, its territories and possessions, and Canada by Barron's Educational Series, Inc.

Original title of the book in Spanish: *Guías Para Principiantes: Pintura de Paisaje* © 2005 Parramon Ediciones, S.A.–World Rights Published by Parramon Ediciones, S.A., Barcelona, Spain. Author: Parramon's Editorial Team Text: Gabriel Martín Roig Photographers: Nos & Soto Artists: Mercedes Gaspar, Gabriel Martín, Esther Olivé de Puig, Óscar Sanchís, Carlant

English translation by Eric A. Bye, M.A.

All rights reserved. No part of this book may be reproduced in any form, by photostat, microfilm, xerography, or any other means, or incorporated into any information retrieval system, electronic or mechanical, without the written permission of the copyright owner.

All inquiries should be addressed to: Barron's Educational Series, Inc. 250 Wireless Boulevard Hauppauge, New York 11788 www.barronseduc.com

ISBN-13: 978-0-7641-5929-9 ISBN-10: 0-7641-5929-1

Library of Congress Control Number: 2005929518

Printed in Spain 9 8 7 6 5 4 3 2 1

CONTENTS

5 INTRODUCTION: The Seductiveness of Nature

6 SYNTHESIS AND RESOURCES

- 8 From Sketch to Landscape
- 10 Formats, Framing, and Templates
- 12 Working in Different Planes
- 14 Harmonizing Color in Landscape
- 16 The Appearance of Depth
- 18 The Importance of the Sky
- 20 The Natural Shapes of Vegetation
- 22 Light in Landscape
- 24 PRACTICE PAGE: The Problem of Clouds
- 25 PRACTICE PAGE: Painting Trees
- 26 Weather Conditions
- 28 PRACTICE PAGE: Painting Shadows
- 29 PRACTICE PAGE: Colors in the Landscape: Communicating Atmosphere

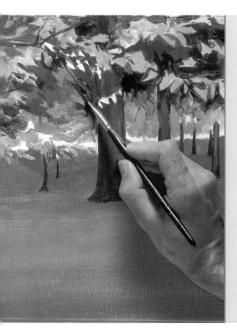

30 PRACTICAL EXERCISES

- 32 Synthetic Treatment of Landscape
- 35 EFFECTS NOTEBOOK: Using Color for Effect
- 36 Landscape with Abundant Vegetation
- 39 EFFECTS NOTEBOOK: Landscape Textures
- 40 Superimposing Planes: Distinguishing Distances
- 43 EFFECTS NOTEBOOK: The Direction of the Brushstroke
- 44 Painting Distance
- 47 EFFECTS NOTEBOOK: Using the Coulisse Effect
- 48 A Sunny Landscape
- 51 EFFECTS NOTEBOOK: Landscape Sketches: A Testing Ground
- 52 Winter Landscapes
- 55 EFFECTS NOTEBOOK: The Color of Snow
- 56 Landscape and Matter Painting
- 60 STUDENT WORK
- 62 The Forest Floor: Effects of Light

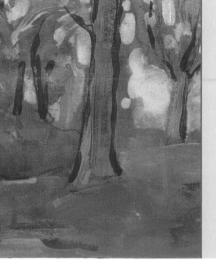

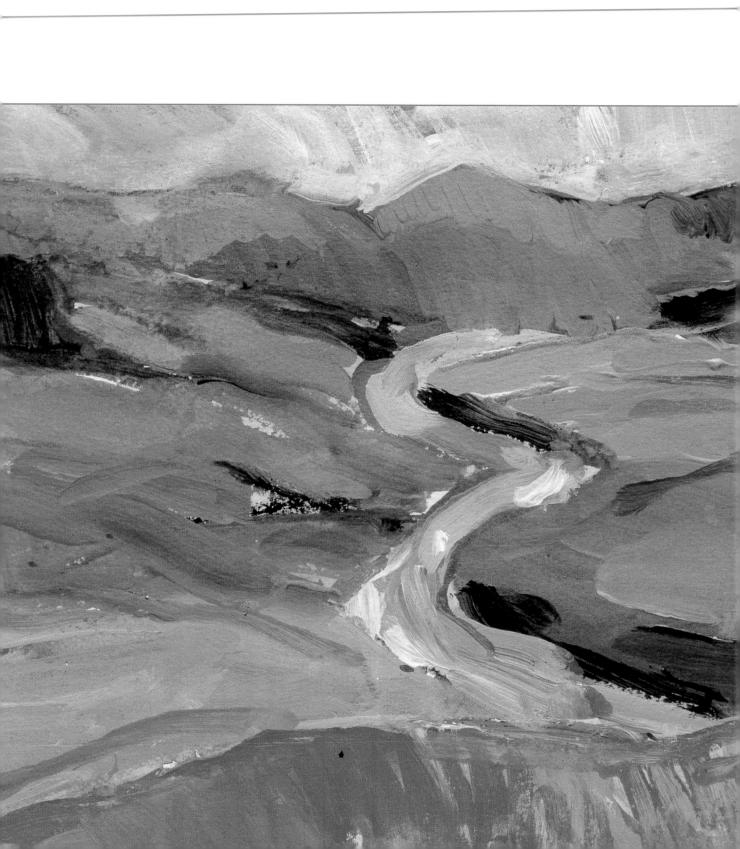

PAINTING

The SEDUCTIVENESS of NATURE

Of all the favorite subjects of artists, landscape is one of the most beloved, especially among amateur artists. However, painting landscape as an autonomous, freestanding subject is a fairly recent development in the history of art. The importance of landscape painting increased throughout the twentieth century.

This interest can be explained in several ways, but landscape's main attraction is its intrinsic beauty, its grand scale, its variability, its shapes, colors, and textures that move us so deeply. For modern-day people, nature is an escape from a gray, industrialized society, a return to our origins. Painting landscapes means discovering the natural environment. This book takes a more basic approach than that of the romantic painters of the eighteenth century, who looked for the fantastic and the exotic in nature.

In modern society, considerable time is devoted to leisure, and as the speed of transportation increases at a dizzying rate, so does our geographic mobility. Some artists use depictions of landscape to record travel experiences and discover new places.

However, this genre cannot be understood in isolation. Landscape is a universal theme; an ideal framework for human activity. Throughout the history of art, landscape has, with good reason, often taken on historic, symbolic, and psychological elements—that is, landscape includes many of the themes that usually are found in other genres.

Another aspect of landscape that fascinates painters is its mutability, the metamorphosis that it undergoes with the weather and the passage of time: a day, the seasons.... A large part of landscape painting's effect lies in how it depicts the interaction between the eternal shapes of the earth and the transitory effects of the weather.

For beginners, landscape is the best genre for starting to paint because it does not require a great deal of academic knowledge or mastery of the strict rules of drawing.

The purpose of this guide is to introduce you to the fascinating artistic possibilities that emerge from the natural environment, to teach you the basic principles of representation, and to allow you to begin painting landscapes confidently, boldly, and without hesitation. With the desire to learn and constant practice, you will gain the skills necessary to paint a broad variety of landscapes. In landscape painting, you will discover a way to understand the nature of the earth—its greatness, its harshness, and its beauty—and to find meaning in it.

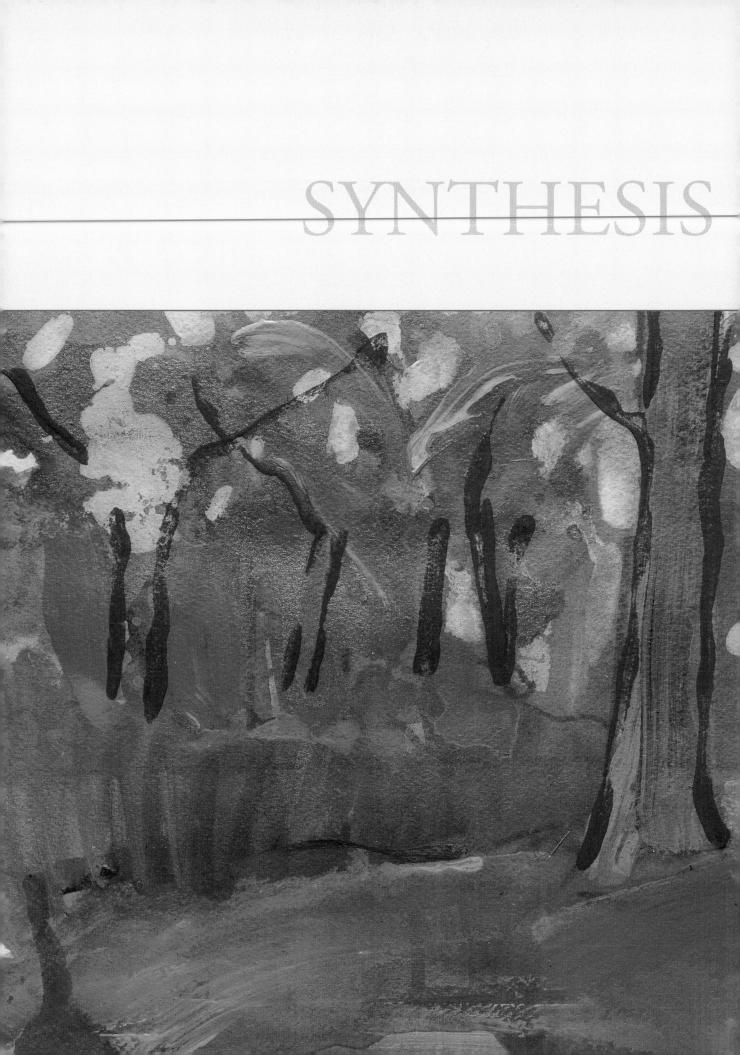

SYNTHESIS and RESOURCES Interpretations of the LANDSCAPE

mann

7

SYNTHESIS AND

From Sketch to LANDSCAPE

All the shapes of nature can be reduced to a few schematic lines. Sketching involves roughly laying out the main features of a landscape on paper. Preparatory sketches, no matter how small or rudimentary, are always useful because they stimulate objective observation and help determine the character of the composition.

An elevated horizon de-emphasizes the sky and focuses attention on the ground.

Synthesizing Planes

Before starting to paint, the artist synthesizes the landscape with a few decisive lines that provide structure to the main composition and the landmarks. The lines should also define the planes. The sketch must be geometric and minimalist, without details or complex shapes.

A few lines are all it takes to locate the main features.

Curves contribute rhythm to the composition and reflect the shapes in nature.

The Law of Curvature

The principle of this law is that all natural shapes are based on curves rather than straight lines. As a result, in order to achieve an appropriate composition, it is necessary, to the extent possible, for the lines that constitute it to be curved rather than straight or angular.

When sketching a landscape, try to identify geometric shapes that allow you to synthesize the outlines of the composition.

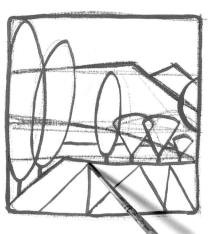

Then synthesize the various planes using diagonal straight lines; the fields and mountains are represented with triangular shapes.

By recognizing these basic shapes in nature, you can create either a preliminary sketch ready for painting or a finished work with flat areas of color.

SYNTHESIS AND

GEOMETRIC SHAPES

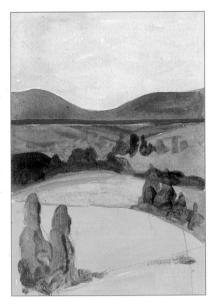

A horizon in the middle distance provides balance between the landmarks.

The Horizon Line

The horizon, where the earth meets the sky, is so basic to our experience of landscape that an abstract painting can be transformed into a landscape merely by dividing it with a horizontal line. Thus, the first line you need to make is the horizon line.

Tip

One way to make sketching easier is to first draw a horizontal and a vertical line that divide the canvas into four quadrants. This helps in locating the center of the picture and the rest of the elements in the proper quadrants.

> A low horizon emphasizes the sky; this is an ideal choice for working with clouds.

An Elevated Horizon

Elevated horizons tend to minimize the sky and emphasize the extension of the landscape. They lend themselves to a descriptive style that individualizes every feature of the terrain. For very flat landscapes, an elevated horizon is often the best choice.

A Medium Horizon

Placing the horizon in the middle of the picture creates a greater balance between the nearest and farthest planes. It is best to avoid dividing the paper into two even halves. Instead place the line slightly above or below the midpoint of the paper.

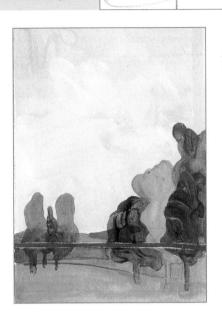

A Low Horizon

A low horizon line allows for few landmarks: You don't have far to go before you reach the sky. The features located in the foreground take on a more monumental appearance.

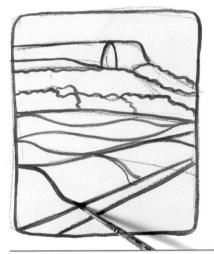

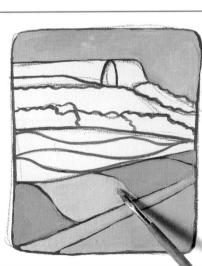

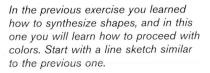

Fill in each segment using the dominant color of the actual model.

Apply the colors flat to achieve a chromatic approximation of the real model. This will give you a better understanding of how the colors function.

Grouping all the elements of the landscape in the center of the painting creates an excessively symmetrical and static composition.

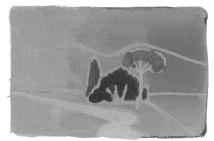

FORMATS, Framing, and Templates

Paintings can be described as open windows to an imaginary world, but artists sometimes forget this when making preliminary sketches. When you paint, you can alter, adapt, or reorganize the format and the framing of the landscape; there is no rule that requires including something simply because it is there.

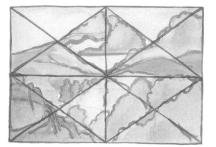

Lorrain's template makes it possible to compose a landscape in a very orderly fashion.

Lorrain's Template

Lorrain's template, a system developed by the French landscape painter Claude Lorrain, consists of a rectangle divided by diagonal lines that cross one another regularly. By adapting the landscape to this scheme, you can create a very harmonious composition.

It is a good idea to offset the subject of the landscape to one side to create a more interesting composition.

Avoiding the Center

It is not advisable to situate the focal point of the landscape in the center of the painting, where the observer's gaze is first directed; offsetting it a little to one side balances the visual attraction and adds interest.

RESOURCES

SYNTHESIS AND

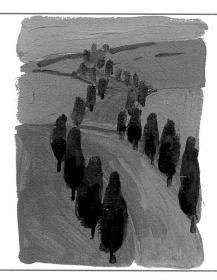

Every landscape must have a rhythm that activates the shapes and adds movement to an immobile scene. This is accomplished through the repetition of a motif, such as trees that line a road.

You can create rhythm by introducing a line that leads the gaze through different planes of the painting. An example is this red road that crosses the landscape.

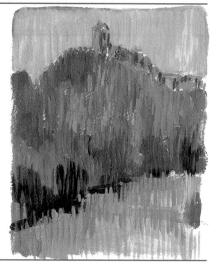

Repetitive brushstrokes oriented in the same direction create a rhythmic surface and give the shapes a more dynamic appearance.

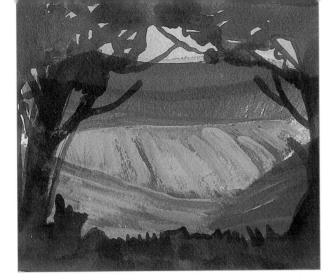

You can create one frame inside another by enclosing the landscape with a few trees located in the foreground. This technique highlights the depth of the painting.

Tip

The format of the work depends on the landscape. Isolated motifs (trees, buildings, and so on) are often treated most effectively using vertical framing, but landscape framing is better suited to broad, deep panoramas.

Framing

One basic rule for framing is that the picture should contain a limited number of elements clearly differentiated by their tone, shape, and size. To choose an effective frame, it is essential to distance yourself from the landscape to get a grasp on its various facets. A broad panorama without too many visual obstacles allows the artist to decide with greater clarity just what its most attractive feature is.

One Frame Inside Another

If you want to direct the observer's gaze to the back of the painting, you can use the traditional technique of creating a frame with a group of trees located in the foreground. This effect heightens the sensation of space; the foliage in the crown of the trees draws them toward the front of the composition and makes the mountains seem farther away. This inner frame surrounds the center of the composition, drawing attention to the center of interest.

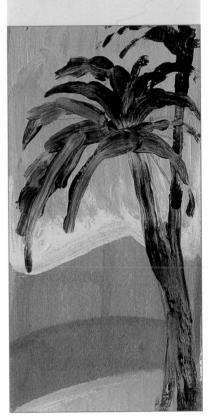

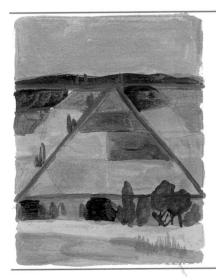

People prefer compositions based on geometric schemes. When it comes to framing, it is best to use a scheme that corresponds to a precise geometric shape.

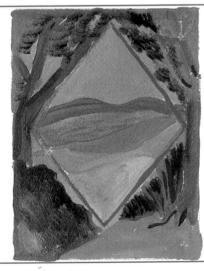

Once the rhombus is established as the basis for the composition, all the elements that make up the landscape must conform to it.

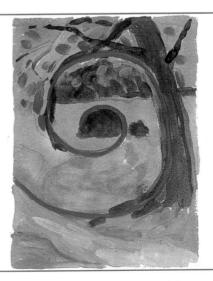

Spiral shapes are less static, and they lead the observer's gaze straight to the center of the painting. This scheme is perfect for creating trees in sinuous shapes.

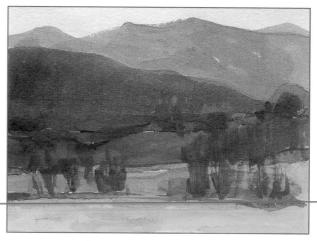

Working in Different PLANES

Warm colors predominate in the foreground, whereas cold ones define the most distant planes.

A landscape is constructed by first superimposing the main planes that make it up. Every plane is represented by a certain color and treatment. Before beginning to paint, you must decide which plane presents the greatest visual interest. Then you must target that area of the painting and organize the remainder around it.

Working in Planes

Space can be represented by dividing it into planes. Planes are divisions in space where items located at about the same distance from the eye are grouped together. To create depth, planes are overlapped, indicating to the observer which one is in front of the other.

Close and Distant Colors

The effect of superimposing planes can be heightened by painting the closest planes in warm colors and the most distant ones in cold colors. Warm colors (yellow, orange, red, and carmine) bring the planes closer to the observer; cold colors (blue, green, and violet) move them farther away. It is difficult to get this color scheme to work in a landscape, but it is a valuable concept with which to familiarize yourself.

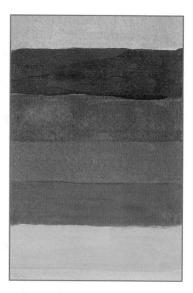

Using an ordered succession of colors, you can highlight the effect of distance in the landscape.

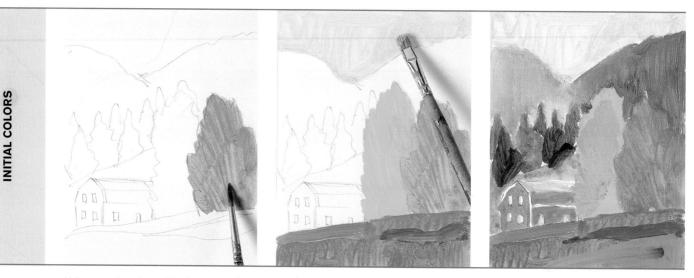

When confronting a blank canvas, the first impulse of every beginner is to cover it quickly. Begin by painting every area with its approximate color.

Cover the canvas with uniform colors, focusing on the trees in the foreground and the sky. Work quickly and with fairly dilute paint.

You can finish the initial coloring in a matter of a few minutes. This will serve as a base for the next layers of color.

12

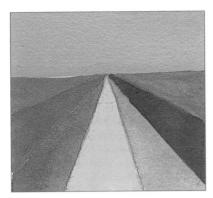

Diagonal Lines in Landscapes

The effect of perspective is easy to create if a clear diagonal orders the features of the landscape from the foreground into the distance. In such cases it is not necessary to create perspective through additional effects because the depth is already indicated clearly enough.

Ways Into and Through a Painting

In a landscape with superimposed planes, you must keep the paint from being too flat and open up routes that allow the viewer to penetrate into the scene. There are many ways to direct the gaze Diagonal lines impart distance to the landscape. All it takes is a few lines oriented toward the same point on the horizon.

Тір

It is a good idea to practice gradations, which are very useful in representing the effect of light on each plane of the landscape.

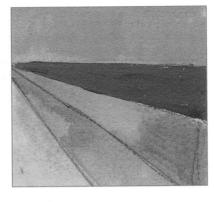

toward the interior of the space and into the depth of a painting. In a landscape, a road or a river that leads toward the horizon is a route through the image.

The Direction of the View

The effect of distance in a landscape is more convincing if it coincides with the direction in which we read. For example, if you are going to place a tree in the foreground, it is natural to use the left edge of the paper so that the viewer's gaze advances in depth toward more distant planes in the landscape.

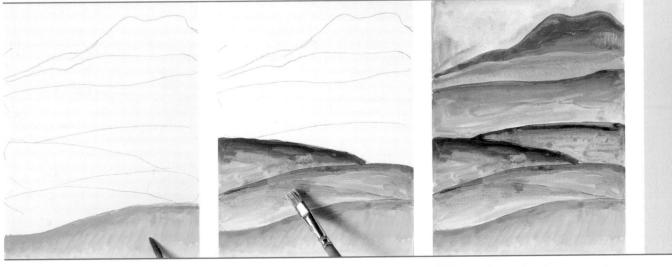

Practice painting the different planes using gradations. This effect is very appropriate for both colorist treatments and realistic interpretations.

Paint each strip of color using a slight gradation–a line of saturated, dark color at the top that gradually lightens as it descends.

White can be used to form a gradation by diluting the colors; a lighter shade of the same color can also be used. This treatment rounds the planes and gives them a more volumetric appearance.

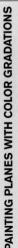

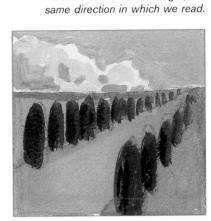

When using diagonal lines to produce the effect of receding space, it is more convincing to draw them from left to right, the

Mixing green with other nearby colors in the chromatic circle (ochres, browns, blues, and yellow) produces a variety of shades.

Harmonizing COLOR in Landscape

Harmonizing color involves painting with a certain color range. The artist's mission is to recognize the chromatic tendencies that exist in nature and to select the proper harmonious color range. This means organizing the colors on your palette to produce the color ranges required in each case.

Painting the Green of the Landscape

When painting a landscape, don't allow your eyes to be deceived by items of similar colors. It is appropriate to exaggerate color variations to make the various elements of the landscape clearly discernible. A painting that contains nothing but greens and colors related to green quickly becomes boring. To avoid this, introduce little touches of other colors that contrast with the green without disrupting the balance (greenish blue or yellow). If you want greater chromatic contrast, reds, oranges, and even purples can be added among the greens to provide variety.

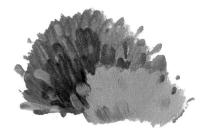

Combine different shades of green to represent a cluster of vegetation.

If you want greater chromatic variety, you can superimpose small touches of other colors onto the green. It is not always necessary to use green in painting a green landscape.

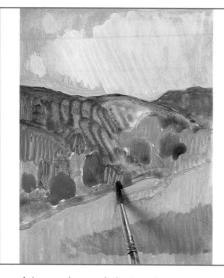

A harmonious painting can be transformed by experimenting with bold contrasts. Let's begin with a composition in a harmonious range of cold colors.

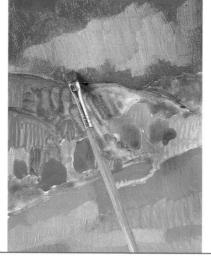

Over the base of bluish colors, the sky is painted in red and the foreground in yellow, intentionally breaking the chromatic harmony. The landscape is completely transformed.

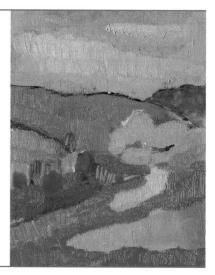

The preceding situation can be corrected by painting the sky in yellow and covering the foreground with red. Notice how this improves the result.

SYNTHESIS AND

The range of warm colors consists of yellow, orange, red, and their derivatives.

The Center of Interest

It is commonly said that every landscape must have a center of interest, or a focal point, like a visual invitation that attracts the observer's gaze. Traditionally, the focal point is located in a middle plane of the landscape, with some elements in the foreground.

The Range of Warm Colors

The range of warm colors is made up of red and its derivatives, because red is considered the color that contains the greatest warmth. It is well suited for the foreground, sunsets, and landscapes depicting intense heat.

The range of cold colors is made up mainly of blues, greens, and their mixtures with other colors.

A tree painted in red on a background dominated by greens and blues turns into a center of interest.

Tip

To paint a landscape, it is not necessary to buy every color available. Quite the contrary. It is necessary to know how to mix select colors accurately so that each one can be used in its entire range of tone and intensity.

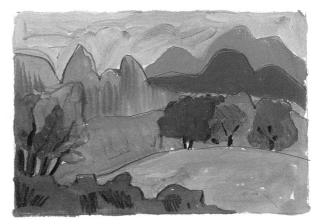

The Range of Cold Colors

The range of cold colors is made up of blue and its derivatives. It begins with green and ends with bluish violet. It is the best color range for painting distant planes, cloudy days, and cold winter landscapes.

The Range of Broken Colors

The range of broken colors is produced by mixing complementary colors in unequal proportions with white. Broken colors are suited to most kinds of representation, but they may be inappropriate for very sunny landscapes that need lots of color and strong contrasts between light and shadow.

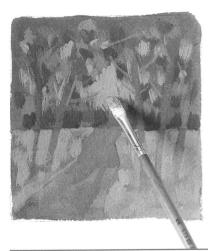

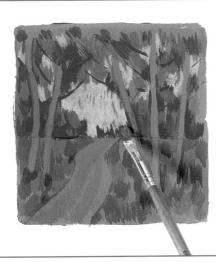

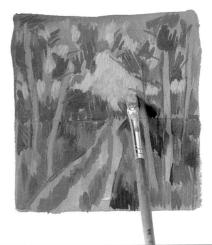

Look at this example of a forest painted in different chromatic ranges. Warm colors such as reds and yellows appear to give off heat.

This forest is constructed using cold colors derived from greens and blues. They give the composition a much more wintry appearance, and the scene appears more somber.

The broken color scale is made up of grayed or broken colors that give the whole composition a harmonious appearance.

The effect of perspective is achieved by directing the diagonals of the landscape toward a single point on the horizon line.

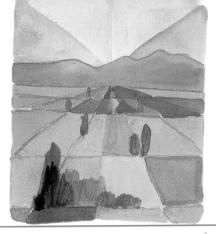

The Appearance of DEPTH

The sense of three-dimensional space is a notable element in landscape painting. An understanding of perspective makes it easier to create the appearance of depth in a landscape. You can also create a perspective without lines, using contrast and definition in the foreground and muted colors in the more distant planes.

Atmospheric Effect

In the more distant planes of a landscape, the colors take on bluish or violet tones. This is an optical illusion caused by water vapor and particles of dust in the air that soften the shapes and colors in the distance to create a mist.

Perspective

The artist's most important device for creating depth is perspective. If you select the proper vanishing point or arrange the features of the landscape in a certain way, viewers are prompted to direct their gaze from the foreground to the background.

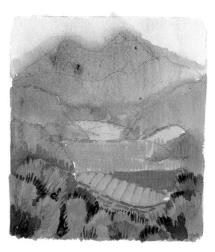

As the planes become more distant, they appear more discolored and out of focus.

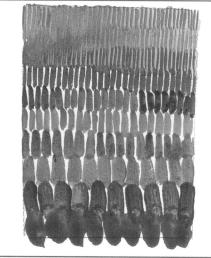

Working with small, thin brushstrokes in the background and thick, dense ones in the foreground, you can create an effect of distance.

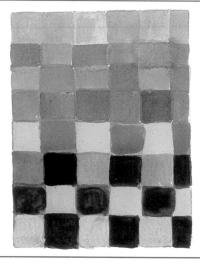

Contrasts among colors are much more pronounced in the foreground; they are softened and may be scarcely perceptible in the more distant planes.

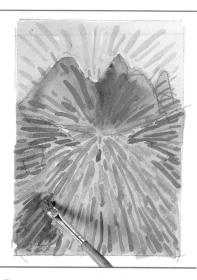

For a more expressive effect, you can make all the brushstrokes in the landscape converge toward a single point located on the horizon line. This is called the vanishing point.

RESOURCES

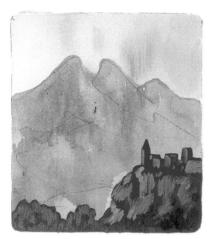

Plenty of contrast in the foreground and a vague background help to indicate the distances in a landscape.

Tip

In Chinese painting, a watery atmosphere dissolves the base of the distant mountains. Thus, the peaks float in the sky while the base disappears entirely.

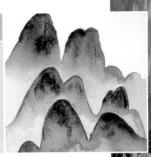

An Empty Background

Usually, the foreground of a landscape is clearly visible, but you must guess or deduce the shapes in the distance. Although the atmosphere hides the shapes, you can see enough to intuit them. This is precisely what a landscape painter does in leaving empty areas without detail: The voids aid in creating a sense of distance.

Contrast in the Foreground

If an element of familiar proportions (such as trees, automobiles, or boulders) is located in the foreground, the observer will be able to compare the dimensions of the near object with the ones located in more distant planes. The colors in the foreground are intense, the textures very noticeable, and the outlines clearly defined. A mist blurs the outlines in the more distant planes.

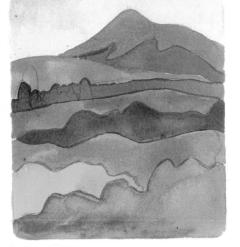

In the coulisse effect, depth is produced by juxtaposing various strips of uniform color in an orderly fashion.

The Coulisse Effect

In French the word *coulisse* is used to designate the curtains and theatrical decorations that span the stage from side to side. This term also describes a composition that simulates the effect of depth by juxtaposing successive planes, similar to curtains in flat colors.

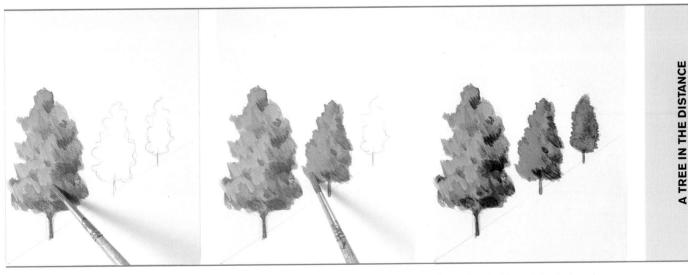

To paint a tree located in the foreground you have to differentiate clearly between the light areas and the shaded ones, add the texture of the leaves, and include a few details. When this same tree is located in a middle plane, the brushstrokes disappear, and you distinguish the shaded area from the lighter one with even color fields. A tree located in a distant plane is rendered as little more than a field of color with minimal differentiation. The distance doesn't allow us to see details, and the shaded areas are scarcely distinguished from the lighter ones. Clear skies commonly are presented using a gradation.

The Importance of the SKY

Even though the sky is flighty and changeable, it is extremely important because it determines the overall nature of a landscape. It acts as a huge window that inundates everything with its light and sets the chromatic scheme, determining the colors that will appear in the painting.

The Shape of Clouds

It is important to pay close attention to the shape of the clouds so that they melt naturally into the surrounding atmosphere. The clouds should not be outlined clearly: It is best to let some outlines stand out from the background and others blend in with it.

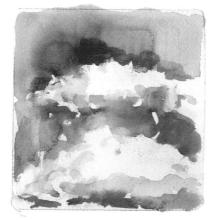

Clear Skies

It is not advisable to paint a clear sky uniformly. Avoid the impression of uniformity by creating a vibration of light and color.

In addition to general harmony, a gradation produces a convincing sensation of light. In a clear sky, the color tends to be more intense at the top (where the blue is more saturated), and slightly lighter toward the horizon, sometimes with a mild tendency toward a yellowish-cream shade.

Clouds should have vaguely defined outlines that stand out in some areas and are blurred by shading and gradations in others.

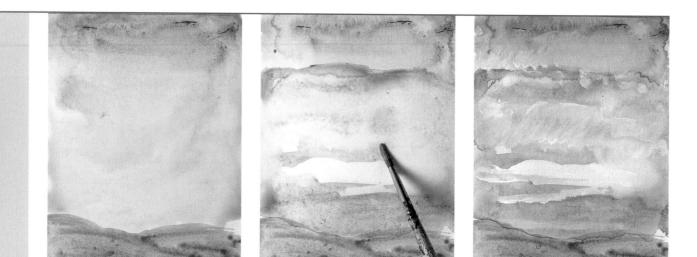

There are two basic ways to paint the sky, one of which involves using washes. Allow thinly diluted paint to flow onto the paper so that the colors blend together randomly.

Using a round brush, apply violet washes over the still-wet blue wash; the new washes mix immediately with the underlying color to form gradations.

With a wet wash, add new colors that will blend in. When these are dry, use white brushstrokes to suggest the shapes of the clouds.

USING WASHES FOR SKIES

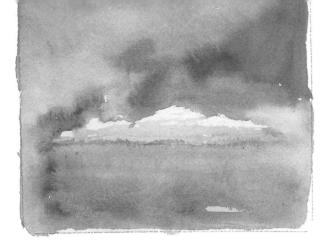

As clouds approach the horizon, they appear more elongated, and their yellowish or violet base blends slightly with the blue of the sky.

Perspective in Clouds

The laws of atmospheric perspective apply to clouds just as they do to landscapes. Because of the effect of perspective, clouds appear more intense and warm when they are high in the sky, and as they approach the horizon their outlines soften and they take on a bluish color. Their shapes also change; they appear smaller and flatter in the distance. The farthest clouds often blend with the mist of the horizon.

An Explosion of Color

The sky often takes on colors other than blue. A sky can be pink, golden, yellow, orange, or greenish, depending on the time of day. This effect is a good one to keep in mind, since the light produced by specific weather conditions determines the general tone of the work. Typically, the most dramatic chromatic effects are seen at sunset.

Tip

Amateur artists often commit the error of rounding clouds so that they appear solid and angular, like piles of rocks placed in a sack. Clouds should not appear solid or lumpy.

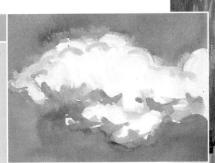

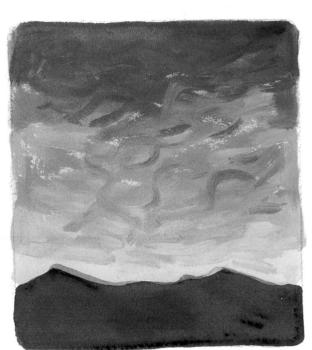

Sunsets are a perfect theme for giving free rein to color and brushstrokes.

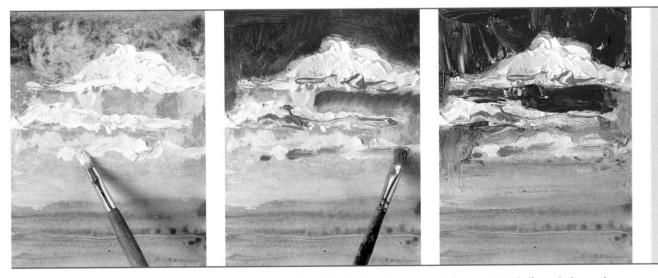

Impasto gives the sky a very expressive appearance. Begin by using lots of paint on the brush and applying the white of the clouds over a sky created with a wash.

Highlight the sky with a darker blue, taking care to avoid coloring over the clouds. Paint the shadow at the bottom of each cloud using striated brushstrokes in violet.

Using a palette knife and ultramarine blue, paint the upper part of the sky in a contrasting blue. The point of the palette knife drags part of the white from the cloud upward into the sky.

The NATURAL SHAPES of Vegetation

Vegetation makes up a major part of many landscapes. It is noteworthy for its varied textures. In addition, if it is painted from a close vantage point, it provides a fascinating richness of detail and color variations. Every tree has a specific growth pattern depending on its species.

Growth Patterns

Regardless of how strange the structure of a tree may appear, it can be simplified into a basic geometric shape. There is a well-defined logic and order to plant growth, which can be synthesized with rhythmic or spiral progressions. When plants grow, they don't extend their branches randomly; the branches share a strong, single impulse, as if released from a nozzle. Each branch follows a certain path at the same time that it makes up an outer curve, the character and proportions of which are peculiar to each plant species.

Avoid minute detail in the representation of foliage, which should be conceived in a few superimposed dashes of color.

To depict vegetation using superimposed layers, apply the gradation effect. This keeps the various planes from blending with one another. The top part of each crown is done in yellow and the lower part in a fairly dark green so that each plant shape stands out against a darker background. Use soft transitions from yellow to green to create gradations in the strips of color. Thus, the yellow stands out in contrast to the darker green of the foliage behind it.

SUPERIMPOSED VEGETATION

It is crucial to learn how to synthesize the shape of trees using economical brushstrokes and color.

Tip

A few details add up to a lot. To paint a branch full of leaves, paint the shape of the whole and then highlight three individual leaves. The eye does the rest.

With distance, vegetation becomes blurry, indistinct, and slightly faded.

Painting Foliage

If you attempt to paint each leaf of a tree, you will invariably produce an image with no vitality. Painting leaves and other details of plants demands quick, expeditious work, with few details and little refinement of what has already been painted. The texture of the foliage is produced through smooth, pronounced brushstrokes that simulate the movement of the leaves. The leaves appear at uneven intervals and grow smaller as they get farther away from their base or origin. You must look for the basic shapes that make up the clusters of leaves and the changes in foliage density.

Vegetation and Distance

A plant in the distance appears as nothing more than a flat blotch of green; along with other blotches, it makes up a pleasant cluster that adds color to the landscape. A distant tree is not a fragment of flat, uniform color, but rather a globular mass of soft or velvety texture, partially veiled in a misty vagueness.

Learning to Synthesize

In drawing trees, it is advisable to use the technique of synthesis, which involves painting with fewer lines—just the necessary ones and checking the model with half-closed eyes to eliminate unnecessary details. It is not possible to paint a tree if you try to depict every mark, hollow, crack, bit of texture, and so forth.

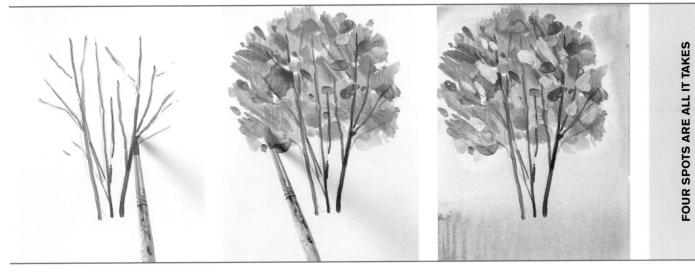

To paint a tree, you merely need to suggest it with a few brushstrokes. Let's look at an example. Using a fine, round brush, paint the trunk and the branches in dark brown.

Next we paint the leaves with small spots of superimposed yellow and red. Their shape must be imprecise, and they must vary in size.

Once the blotches are dry, apply brushstrokes in white that simulate the passage of light among the leaves. Paint the background in ochre. This tree was created in scarcely two minutes.

Lateral light

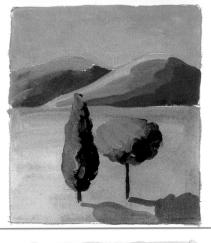

LIGHT in Landscape

Overhead light

As the day progresses, a landscape is subjected to different light, which varies according to the position of the sun and the atmospheric conditions. It is worthwhile to understand these factors, especially how variations in the position and intensity of the universal light source the sun—affect the landscape.

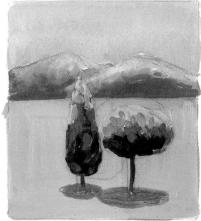

Lateral Light

Lateral light occurs when the sun strikes the landscape from the side and from a fairly low point in the sky. Sharp contrasts between light and dark reveal the shape and texture of the landscape and offer a broad range of descriptive shadows that help define the areas surrounding the objects. The parts of the vegetation that face the light source are illuminated.

Overhead Light

Overhead light is when the sun is located at its highest point in the sky. The violent brightness of the noonday sun shrinks the long shadows characteristic of lateral light. The lightest and warmest areas of the tableau are the shapes that form a right angle with the light.

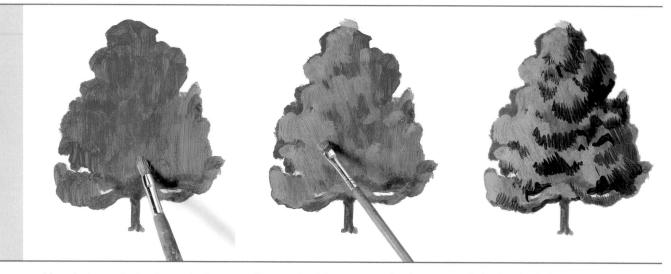

Many features of a landscape invite treatment as three-dimensional shapes, which have their own volume. To highlight the shape of a tree, first paint it with a flat green. Use a yellowish green to paint the illuminated areas of the leaves in an impressionistic manner. This highlights the volume of the tree.

Paint the shaded areas, distributing the contrasts in such a way that some parts of the landscape advance outward while others recede into the background.

Frontal light

Frontal Light

Frontal light comes from behind the artist and causes the sky to appear darker. The foreground of the image is seen most clearly, and its tones deepen and cool off as the shapes recede into the distance. The shadows are hidden behind the features that make up the landscape.

Tip

Shadows from sunlight move with the sun; this means that the shape and the length of the shadows vary with the passage of the daylight hours.

Diffuse light

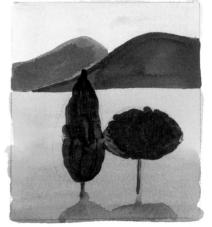

Backlighting

Backlighting

Diffuse Light

Because of the filtering effect of clouds, diffuse light reaches objects in an evenly sifted fashion. In these conditions, the shadows appear softer, like dark, indistinct halos created with blends and gradations.

In a backlit scene, the light reaches the model from behind and shades the planes visible to the artist. The sky in the scene is the brightest area. Backlighting reduces the features of the landscape to a series of dark shadows that stand out as silhouettes. The tone of the ground lightens as it approaches the horizon.

THE COLOR OF SHADOWS

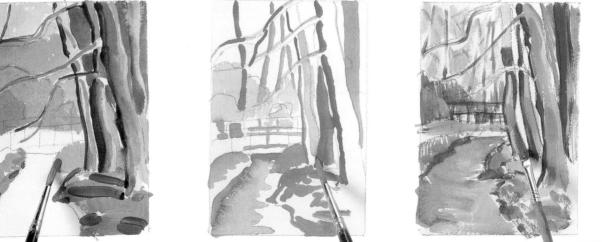

The tonal value of shadows commonly is brown-that is, a shade similar to the feature represented but mixed with a little black, brown, or gray.

Since the shadows appear to have a temperature opposite that of the light source, they can also be painted in blue.

A more colorist treatment creates a greater chromatic impact. Instead of working with cold, subdued colors, try painting the shadows in red.

The PROBLEM of CLOUDS

Much of the attraction of clouds stems from the voluptuous shapes they take on. Cumulus clouds appear solid, have volume, and owe much of their majesty to the sun, which illuminates them and gives them their characteristic shape. Painting clouds involves synthesizing, abbreviating, improvising, and imagining; it is really an exercise in interpretation, a way of transforming nature using shapes and colors. Let's see how to paint a sky filled with storm clouds.

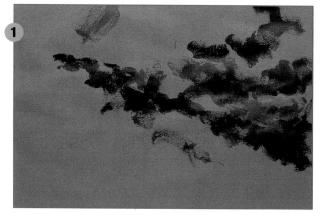

1. Working on a blue canvas, sketch a few fine lines in pencil. Use a deep purple to paint with agitated strokes.

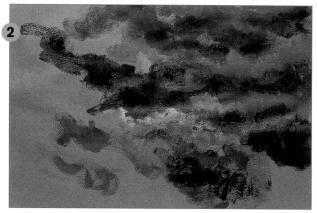

2. Leave some small areas where the intermediate tone of the original blue is visible. Use white sparingly to introduce the first light areas.

Inexperienced painters should not trust to improvisation: it is a better idea to first draw the shape of the cloud in pencil. Beginners should also spend a few moments studying the direction of the light and paint the shadow in a shade of violet.

Paint the body of the cloud by adding white with very quick brushstrokes similar to small, curving whiplashes. The white takes over the upper part of the cloud and fuses with the violet in the intermediate zone.

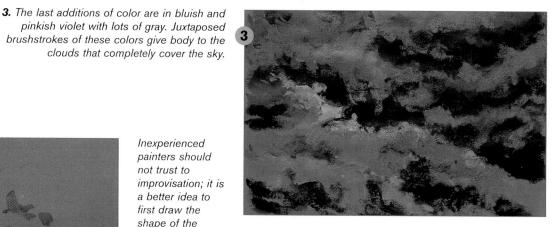

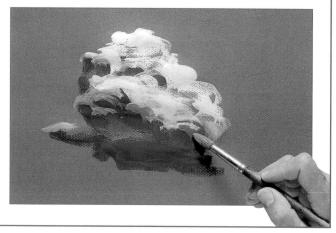

PAGE

PAINTING TREES

Trees located in a near plane can be created using a series of brushstrokes or impasto. It is crucial to control the direction of each brushstroke. Study these three examples done in oil. This is an opaque medium that makes it possible to redo and retouch using light colors over dark ones. That quality makes oil ideal for painting the crown of these trees without fear of making mistakes.

2. Below the previous colors. paint the shaded leaves using violet and medium green impasto mixed with magenta. yellow, ochre, and brown. Paint the

3. Apply the final touches with a finer brush. Pay particular attention to the branches illuminated by the sun; they appear orange.

1. In a palm tree the trunk takes on great importance. After doing the initial sketch, trace the trunk's curvature using slightly orange sienna and a firm brushstroke. Paint the first leaves using short brushstrokes in the shape of a comma.

in pencil. Apply

brushstrokes of

trunk with a pale ochre.

a few initial

2. To suggest the willowy texture of the palm leaves, use a distinct zigzag motion as you apply the colors. The fruit appears as rounded, even blotches of orange and areen.

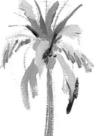

3. Finish up the palm tree by using burnt umber to darken the top of the trunk. Complete the foliage with brushstrokes of purplish paint that are much less precise than the previous ones.

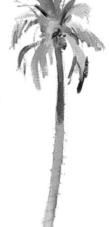

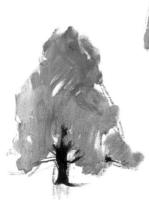

1. Cover the crown of the tree with ochre paint mixed with turpentine, then add green and a touch of red to form gradations. The trunk is painted in burnt umber.

2. Once the base dries, use dark green to cover the areas of foliage that receive the most light. The brushstroke must be thick and compact. Refrain from painting in the other areas.

3. Finish the darkest areas of the tree with burnt umber. The new brushstrokes are more agitated than the previous ones, and they leave small light areas.

The effect of sunlight on the landscape is created by heightening the contrast of the shadows.

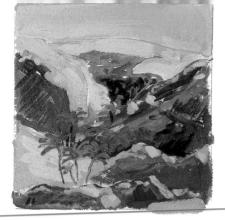

Weather CONDITIONS

Climatic conditions determine the appearance of the landscape by imparting transitory effects. The weather infuses the landscape with life and character, and everything that suggests immobility, stability, and solidity in nature disappears.

Sunlight

The presence of shadows is an important part of depicting a landscape bathed in strong sunlight. On sunny days there is greater contrast between the temperature changes; that is, the warm colors (in the sunlit areas) and the cold ones (in the shadows) are more lively and harmonize less with one another.

Painting Rain

In oils, a heavy rainfall can be indicated by making diagonal lines on the layer of paint with the point of a palette knife. A wash is commonly used to create an intense atmosphere that makes it hard to distinguish the outline of the landscape features. A few lines can then be added to suggest falling rain.

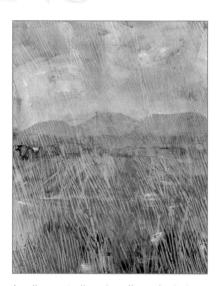

In oils or acrylics, the effect of rain is created by superimposing soft linear brushstrokes over the landscape.

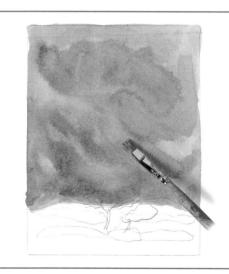

Creating a storm requires working quickly, using dynamic brushstrokes and expressive impastos. To begin, paint the sky using irregular washes in shades of violet.

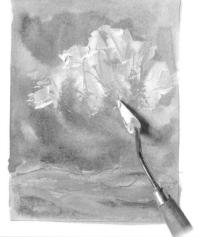

Over a dried background, apply impastos of white paint using a spatula, with a more opaque white in the top of the cloud and a more transparent white in the lower part.

In new additions of impastos, randomly mix in red, blue, violet, and white. Use the point of the palette knife to add sgraffito, heightening the dynamic effect.

SYNTHESIS AND

Snow Snow reflects light and breaks up

the ground into strong patterns of light and dark. On steep terrain it creates interesting shadows because it reflects the irregular contours of the land it covers. In painting snow, avoid infusing everything with white. Instead, create an illusion by shading white with blue, orange, pink, and yellow. Since snow is white, it reflects sunlight in the lightest areas, and light from the sky in the shadows, thereby presenting different chromatic values. For example, in sunrises and sunsets, the light reflected by the snow is pink or orange.

loaded with leaves into a dynamic feature moved by invisible forces.

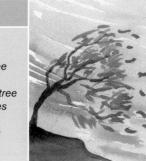

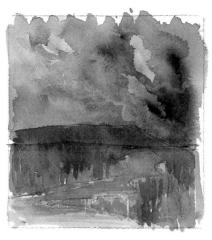

Foggy Weather

Fog or mist is depicted using delicate and nearly imperceptible effects, subdued colors, and diffuse shapes that require a sensitive treatment. A landscape obscured by fog appears in gradations, with more precise shapes and broken colors in the foreground and nearly indistinguishable profiles and bleached colors in the background.

Stormy Weather

Storms can transform a peaceful place into a scene of drama and contrast. The violence and the speed that characterize storms are commonly expressed through lively, descriptive brushstrokes that reinforce the agitation in the landscape. As for the sky, storm clouds move at high speed, and they should be painted quickly.

Tip

Wind creates movement as it travels through the landscape. It changes a static tree

With a wash used to depict rain, diagonal brushstrokes only partially

cover the background.

Stormy skies are

and they darken

the colors of the

landscape.

dominated by aravs and violets.

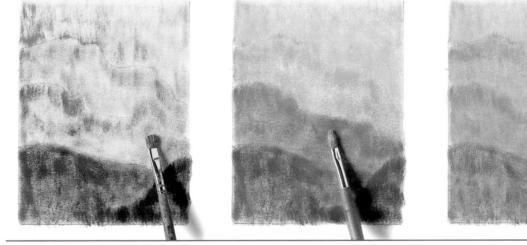

A dry brush is very appropriate for painting diffuse profiles and is an ideal tool for creating fog. Apply a different color in each plane.

Over the original colors, add dry glazes that cover the white of the canvas more effectively.

PAINTING SHADOWS

If you stop to analyze any landscape, you will see that its volume and shapes are the product of a combination of surfaces sculpted by light and shadow. The key for recreating the light involves reducing the effects of shadow on the landscape to four basic conditions. Let's look at a few examples.

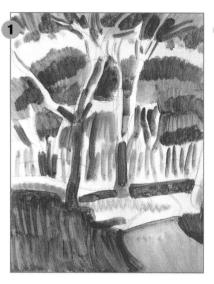

1. One traditional method involves first painting just the shadows with blue; the borders between light and shadow are created by defining the shaded areas with absolute precision.

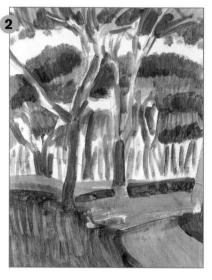

2. As a foil to the bluish shadows, bright orange is added to cover the areas bathed in intense light. The indications of light serve not only to highlight, but also to provide an initial spatial impression of the landscape.

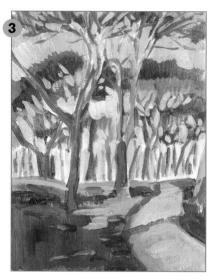

3. Reds, ochres, and yellows are added in the illuminated areas, and blues and violets in the shaded ones. The representation of a shape in space depends on the relationship between warm and cold colors.

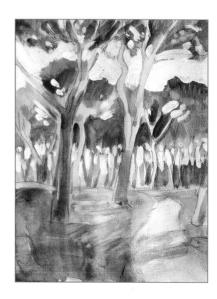

In a tonal approach, shading is done in brown, gray, or black, and the color of an object is gradually darkened without excessive contrast. Modeling and chiaroscuro effects can be useful with this technique.

Another way to approach shadows is to paint the impression of the light with a pale ochre over a bluish background. The impression of the light depends on the contrasts. A sharp increase in the brightness of a color is accepted as an indication of light.

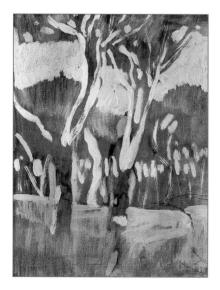

PAGE

PRACTICE

COLORS in the LANDSCAPE: Communicating ATMOSPHERE

Every landscape painting has a characteristic atmosphere determined by the interaction of color and the artist's interpretation and treatment of the scene. When you paint a subject, try to capture the atmosphere and transmit the feelings of the place with chromatic keys. You can transmit the atmosphere—a sunny day, a sunset, a cold winter's day, or a landscape under a hard rain through color and certain effects and brushstrokes.

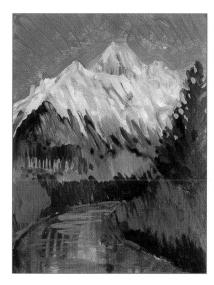

A sunny day can be depicted in a tonal manner, without excessive chromatic exaggeration. The colors of the vegetation are produced using various greens mixed with yellow and browns. The illuminated areas (mountain, vegetation, and reflections in the water) are differentiated from the more shaded ones (the edge of the river and the fir tree on the right).

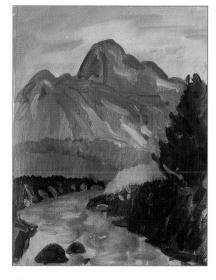

The sunset completely transforms the same landscape. It bathes the surfaces with a reddish light created with warm tones and fiery colors. The contrasts in the shaded areas along the edge of the river and the fir tree are darker, setting up a kind of backlighting.

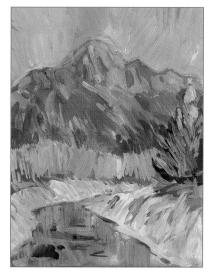

Despite the orange reflections on the mountain from the sun dipping behind the horizon, the painting is completely dominated by blues and violets that communicate a sense of winter cold. A denser, more generous brushstroke helps represent the texture of the snow.

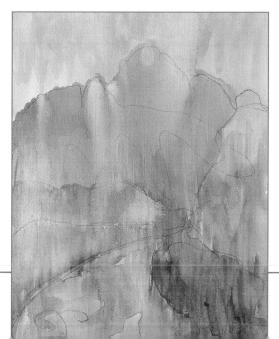

Because direct sunlight is the main color activator, rainy days impart grayish colors to the landscape. The curtains of rain melt the colors and soften the outlines. The watery atmosphere allows us to see only a spectral image of the landscape. In such cases, working with washes is the best choice. PAGE

PRACTICE

PRACTICAL

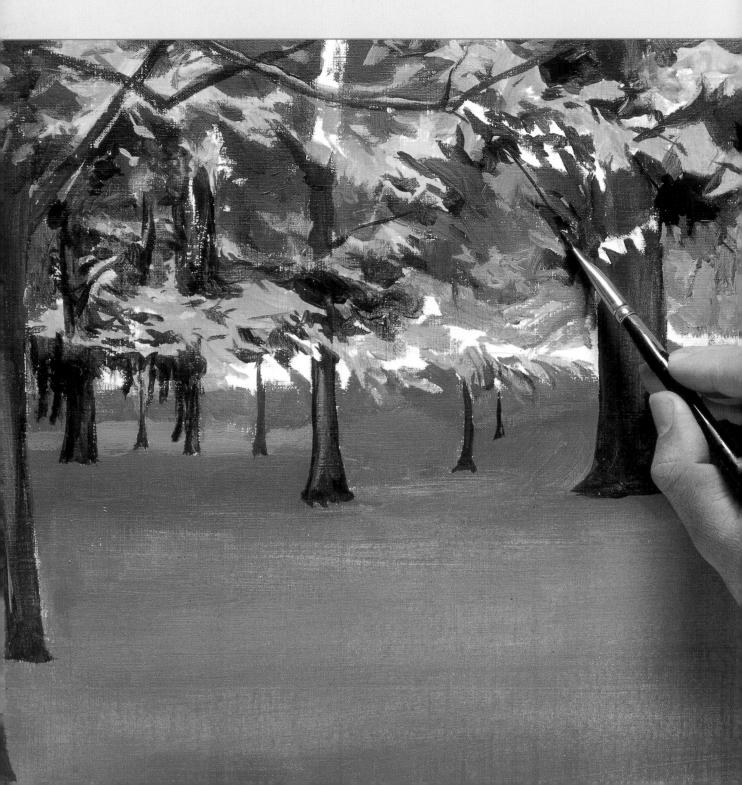

EXERCISES PRACTICAL EXERCISES

In this section you will develop the basic techniques for successfully painting a natural landscape. You will learn how to represent vegetation located in different planes, use chromatic effects, and create the impression of distance and atmosphere. You will see how the visual impression of the colors, the direction of the brushstrokes, and the degree of definition combine to produce the desired effect. You will also practice a number of techniques and tricks that can be used to express the unique character of different landscapes.

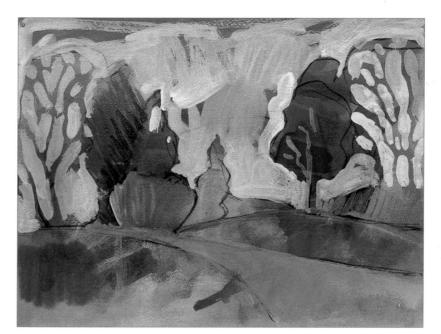

PRACTICAL

SYNTHETIC

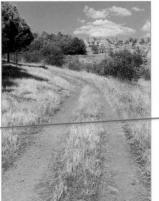

SYNTHETIC Treatment of LANDSCAPE

When using oil paints, it is possible to synthesize the shapes of the landscape perfectly with just a few areas of color and practically no details. The shapes of the vegetation, although flat, are outlined and barely suggested by two or three superimposed tones. This method should be used for any landscape that requires a great degree of elaboration, especially because it allows for a quick, immediate resolution of the first phases of the painting. Don't be concerned if, in the initial coloring, it appears that all the brushstrokes stick together; if you carefully follow the suggested steps, this exercise will be easy.

The initial sketch of the landscape is very simple. The drawing, done with a grease pencil, involves a few curves that describe the cart tracks in the road and other voluptuous, circular shapes to locate the vegetation.

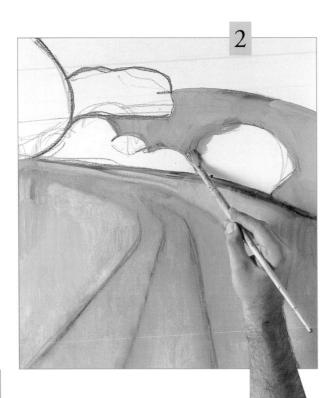

Тір

The technique of working in patches of color is especially applicable with subjects that present somewhat abstract shapes, such as superimposed clusters of vegetation.

Begin by covering the ground with a raw sienna slightly diluted with turpentine, leaving the sky and the vegetation white. For painting this area of the picture, a medium brushwhether round, flat, or cat's tongue-is best, although if you prefer you can use a broader one.

EXERCISES

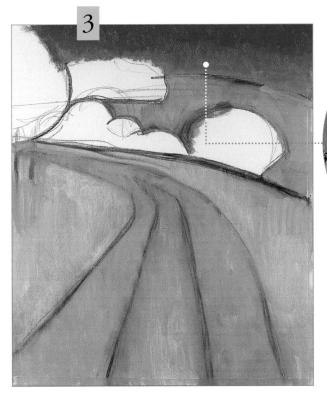

Paint the sky with ultramarine blue and cyan, applied to form a gradation. Many professional artists choose to lighten the shade when the sky is all one color, a trick that gives the landscape more interest.

For the gradation in the sky, apply the darker color at the top, a medium shade in the middle, and the lightest blue at the edge of the hills. Once the colors are applied, you simply have to go over them repeatedly with the brush to smooth out the transitions from one shade to the next.

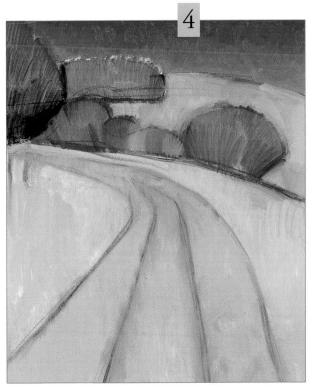

By mixing permanent cadmium green with browns, you can create different greenish shades for painting the vegetation. The color is applied diluted with turpentine. The color contrasts describe the structure and the shape of each cluster.

Paint the fields of dried grass on the reddish background using an ochre mixed with white. The color is mixed with a little turpentine and applied flat on the hill in the background. In the foreground the brushstrokes are thicker; they are applied in short, vertical strokes to recreate the texture of the grass.

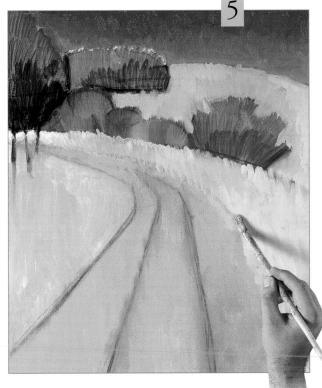

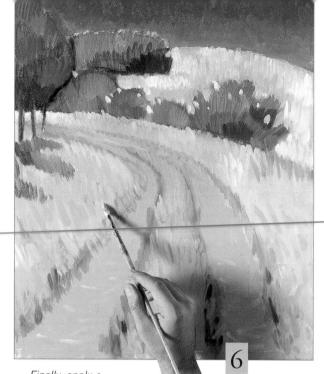

Finish up the grass in the foreground with new additions of slightly yellow ochre. The ruts of the road are left the same color as the background to create contrast. Using burnt umber, paint the edges of the road to make it stand out more.

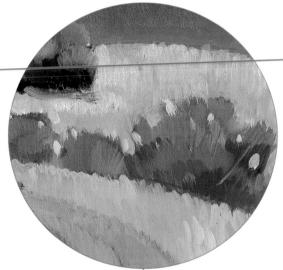

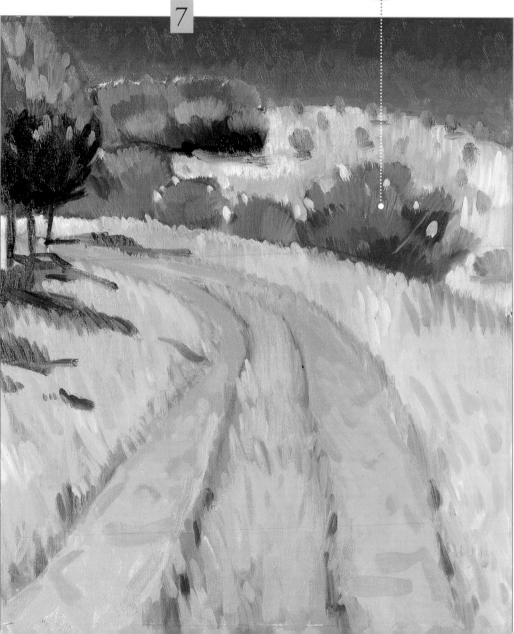

Finally, apply a few touches of thicker, light green paint to the crown of the pines and a violet gray to the shadows that project onto the grass. A few brushstrokes with orange ochre and yellowish ochre produce a gradation in the reddish dirt of the road. The coloring is now finished.

Finish the vegetation by superimposing new variations of green over the previous ones. Finish the irregular profile of the plants by adding small, light touches of paint onto the green to suggest spaces through which the background color is visible.

EXERCISES

Using COLOR for EFFECT

Using colors to define the main chromatic areas of the landscape is one way to quickly cover the white of the canvas. As you continue to work on the painting, you can finish the colored areas with lots of details. To better understand color technique, let's look at several tremendously simple ways to apply colors.

Use paint thinned with turpentine to depict vegetation. You can use different shades of green to represent the light that reaches each area.

If you wish to differentiate several planes of vegetation, give each area a different color and present the planes as overlapping one another.

In certain areas the underlying line from the grease pencil or charcoal is visible. This is not a problem. In many cases, these lines give the work more graphic interest.

A green blotch turns into vegetation when the background is painted with thicker paint. Light ochre is used to outline the plant and apply spots onto the green to suggest spaces among the leaves.

It is very easy to create a gradation in the color of the sky. The top of the paper is painted with a deep blue.

Moving down the paper two more blues are applied: a medium one and a light one.

The three strips of blue are merged by simply going over them with the tip of the brush.

These brushstrokes show the direction of brushstrokes to be used in creating gradations in the sky.

EFFECTS

LANDSCAPE with

LANDSCAPE with Abundant VEGETATION

A landscape with lots of vegetation allows for a certain amount of experimentation, such as color changes and even variations in proportions, without compromising the final result. You must select suitable colors, which do not always need to be green or brown, and apply them to the canvas using brushstrokes appropriate to the shape of the trees and the texture of the foliage. The versatility of oils makes them the best medium for this exercise.

Paint an orange background using acrylic for quick drying. The first line on the canvas, done in charcoal, clearly establishes the main areas of the landscape. This involves identifying planes and outlining the shape of the mountains.

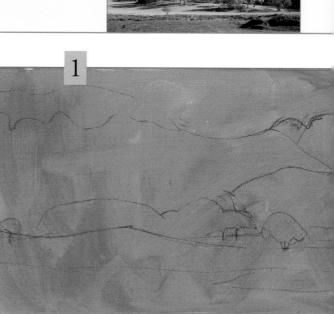

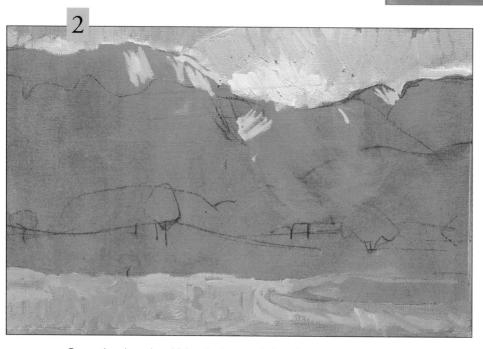

Cover the sky using thick paint in a gradation of a little ultramarine blue and lots of white. The brushstrokes should not completely cover the background, but they do define the shape of the mountains. Mix yellow, white, and green and proceed in the same fashion to cover the meadow at the bottom.

Tip

The colored background is done in acrylic; that way, it dries quickly and you can start to draw with a stick of charcoal. Working on dry paint, you can make as many corrections as you need. To erase, simply go over the area with a clean cloth.

EXERCISES

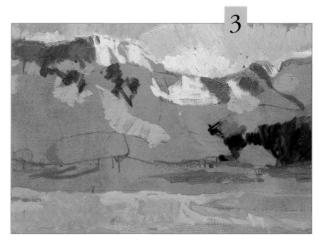

Paint the light areas and the shadows on the mountains. The shades used should be an extension of the ones in the sky: a good variety of violets and whites broken with ochre and blue. Instead of covering up the orange background completely, leave small light areas that highlight the relief on the rocky surfaces.

> Paint the vegetation using shorter, superimposed brushstrokes, and paint the meadows with additions of a flat color that covers well. Paint the shadows cast by the trees, leaving spaces through which you can see the underlying grayish green.

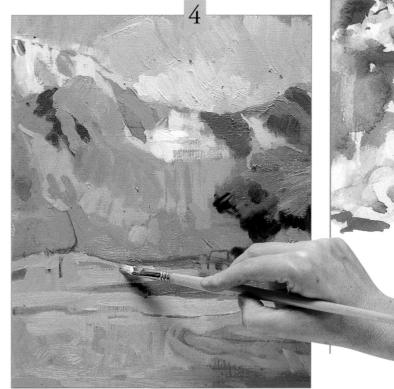

Finish the coloring with slightly diluted paint. This involves covering the canvas quickly with imprecise additions of color. The sketchy treatment of these varied green spots serves as a basis for later stages in the painting.

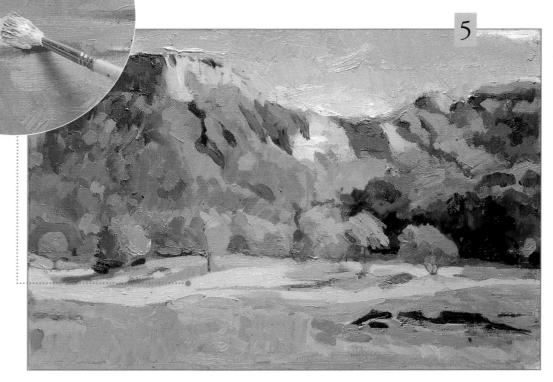

Using thicker paint, flatten the spots of color and differentiate each plane with new additions of color. Thus, the mountains appear ochre, yellow, and violet on top; pinks are predominant in the middle zone; and in the foreground there are new variations of green.

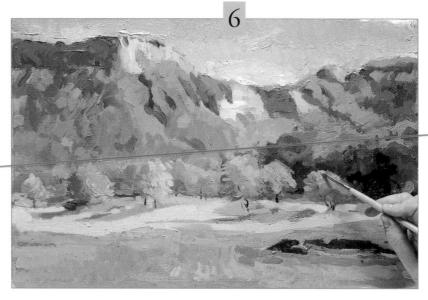

Tip

To eliminate traces of brushstrokes in the sky, all you have to do is pass the edge of a palette knife over them to smooth out the surface of the painting.

The vegetation close to the observer needs greater detail. Using a fine, round brush, superimpose strokes of paint to help communicate the texture of foliage. Notice that many of these trees are done using juxtaposed patches of color in the form of tonal gradations.

A painting with a great variety of color can achieve a very finished look if you use the right coloring techniques, always working from the general to the particular. The details should not be added until the last stage: Using a fine brush loaded with color, give greater relief to the nearby row of trees. The trunks of the nearby trees are not done in paint, but rather by drawing onto the wet paint with a stick of charcoal.

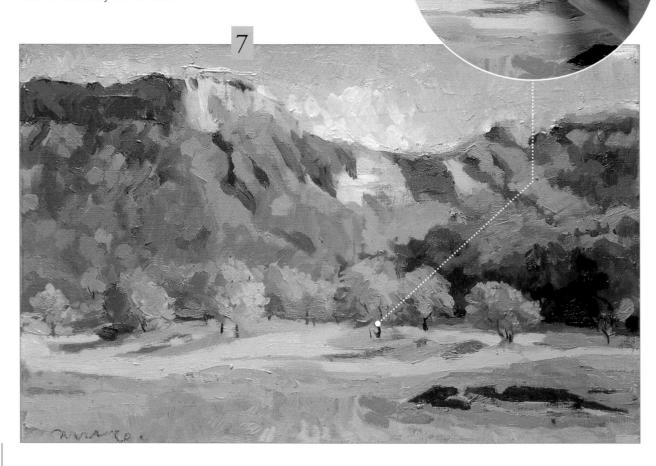

LANDSCAPE TEXTURES

Expressing the proper shape and texture of each element in the landscape makes it possible to identify the various plant species. This commonly involves a certain degree of synthesis; it is not merely a question of color but also the manner in which it is applied. In order to describe a texture, you must use the appropriate techniques for your subject.

A carefully depicted tree takes on a volumetric appearance and shows a clear differentiation between light and dark areas. The successive slanting brushstrokes indicate the location of the light source.

The trees in a middle plane can be represented as compact masses. The effect of volume is achieved by gradations in the green from light to dark. The texture is suggested by the brushstrokes.

It is important to develop your ability to synthesize shapes. Carefully study the shape of every species of tree so the observer will be able to recognize them. Then use a few brushstrokes to synthesize their characteristic shape. The direction of the brushstrokes must follow the direction of leaf growth.

A few fine brushstrokes suffice for painting a stem and a cluster of greenish patches in a pattern to represent the foliage. It is important to leave some open spots among the leaves so that the background color has room to breathe. eaf

In the preceding exercise the vegetation was painted using oil impastos without marked contrasts. The direction of the brushstroke is basic in depicting the foliage. To represent the trunk, you simply add a sgraffito line with the wooden tip of the paintbrush handle. The diagonal brushstroke is very common, and it matches the lateral light source in the landscape. It does not indicate the texture as much as the direction of the light that bathes the leaves. In this sketch, unlike the previous one, the trunk is drawn in charcoal. EFFECTS

EXERCISES

PRACTICAL

Superimposing PLANES: Distinguishing Distances

Superimposing

Superimposing planes and shapes, such as hills and trees, creates an illusion of depth. The eye perceives the superimposed shapes as located one behind the other, in planes that recede progressively from the observer. Shifts in luminosity or color can heighten the appearance of depth in the landscape. In the following exercise, you will learn how to apply this concept and control the colors in each plane. The medium used is oils.

> Devote more time to drawing if the model requires it. Begin by working very schematically, depicting every plane without slowing down for details.

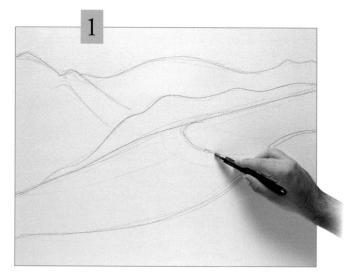

Tip

Once the drawing is done, it is a good idea to begin painting the sky with a gradation of blue.

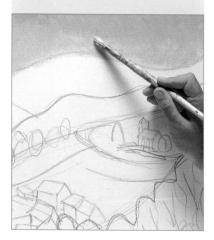

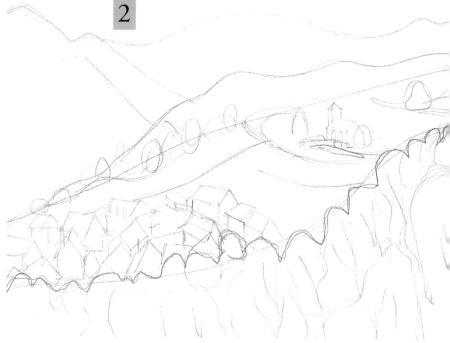

Adding to the sketch, locate the clusters of houses, the trees in the middle distance, which are represented with circular shapes, and finally the approximate position of each tree in the foreground.

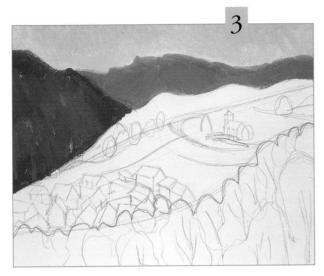

While the violet color base is still wet, add relief in the mountains by applying lighter shades of violet in the illuminated areas and darker ones, some mixed with green, in the shaded areas.

Using flat colors, fill in the most distant planes. Use violets, the shade landscapes tend to present in the distance. The farther away the mountains are, the lighter the violet becomes.

Paint the meadows with various flat, medium greens that present little contrast but describe the terrain.

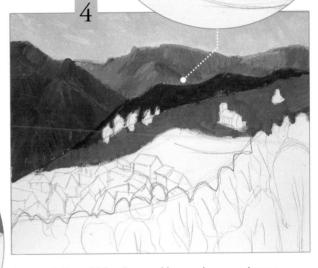

Approach the middle planes with raw sienna and green. The colors are applied opaque and flat-that is, without any gradation. Omit the trees and buildings and leave the spaces for them blank.

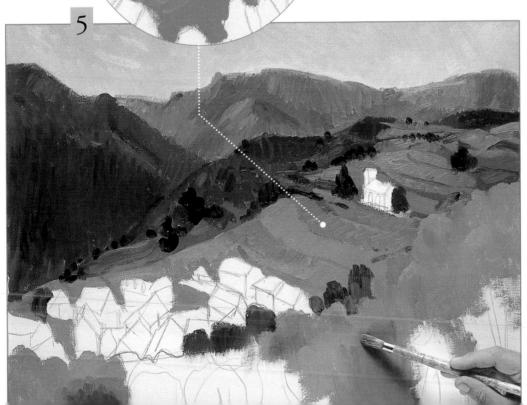

Finish up the fields in the middle using broad strokes of greens that are clearly differentiated. The distant trees appear in greater contrast. Paint the foliage of the cluster of trees at the bottom using spots of color that blend together.

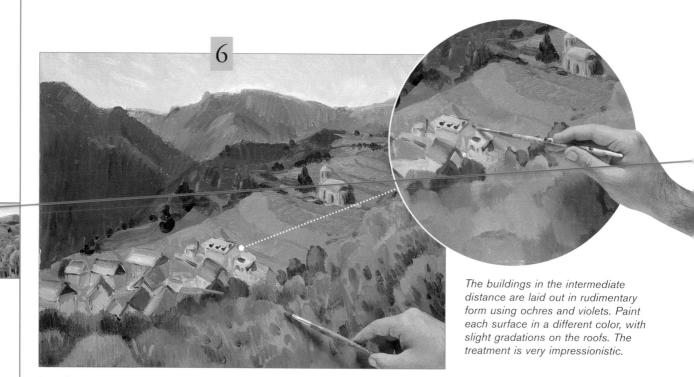

In order to distinguish the green of the trees in the foreground from the fields in the middle plane, we add more yellow and ochre to the foreground. The warmer the color, the closer it appears to be.

Finish up by adding more brushstrokes in the vegetation of the foreground to create a greater effect of texture. Add short brushstrokes of ochre and yellow impasto over the initial greenish spots to create the appearance of leaves.

Tip

For a more refined treatment of the trees in the foreground, use a fine, round brush to add long, directional brushstrokes.

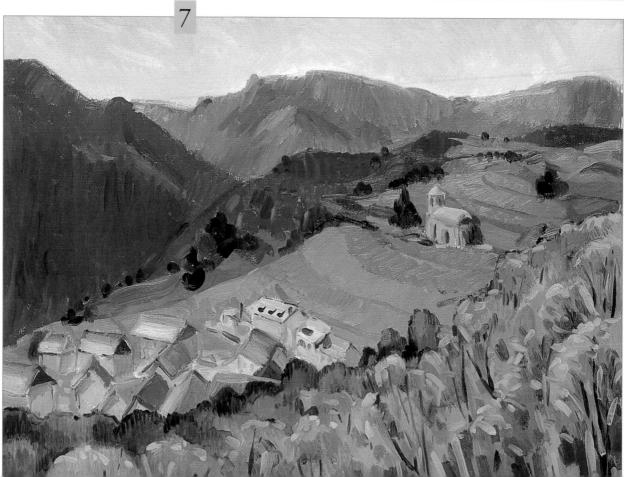

The DIRECTION *of the* BRUSHSTROKE

In painting a landscape it is not enough to use the proper colors; you also have to decide on the direction of the brushstrokes to depict the terrain and the texture of the surfaces most effectively. A general rule is that the brushstroke always follows the direction of the surface it describes. To better understand this concept, let's look at two landscapes painted with fine, linear brushstrokes.

In this scene, the general direction of the brushstrokes helps highlight the roundness of the hill.

The brushstrokes in the foreground are more pronounced and their direction is very clear, in an effort to reproduce the land covered with dried grass.

The second model is a view of a beach with a small pond, a rocky outcrop in the background, and a smooth, clear sky.

The brushstrokes in the sand depict the undulations of the terrain and highlight the effect of depth by moving toward the same point on the horizon line. *In the sky the brushstrokes appear voluptuous and undulating to represent the effect of the clouds.*

The vegetation in the background is painted with curved, superimposed brushstrokes. They communicate a rich texture.

The smooth sky is painted with a succession of diagonal lines intended to reproduce the direction of the light, the sunbeams in the sky.

The pond is depicted using washes. The absence of line contrasts with the roughness of the sand, indicating the different surfaces. EFFECTS

Painting DISTANCE

Painting

Watercolors are the ideal medium for creating subtle gradations of shade and color using a spontaneous, direct technique. This medium is thus very appropriate for representing changing atmospheric conditions and the effect of distance in a landscape subjected to the pale light of a cloudy day. The subdued colors and soft outlines in the distant planes are produced by adding more water to the color. Let's get some practice with watercolors.

horizon line, then the shape of the mountains, and finally, a few lines that locate the major features of the terrain.

very evenly.

to spread out the color

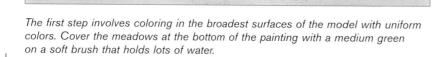

Do a simple pencil drawing. Begin by drawing the

EXERCISES

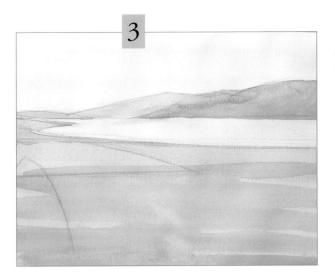

Use violet to paint the farthest plane; the mountains on the left are done in a lighter shade because they are farther away from the observer. The sky is faintly colored in the same shades used on the mountains, but highly diluted with water.

Tip

With watercolors, painting with a reduced number of colors does not mean that the work will have a limited chromatic range. On the contrary, you can create a multitude of secondary colors and shades by superimposing glazes.

Add a transparent purplish wash to the sky to suggest the presence of clouds. When the green at the bottom of the painting is dry, superimpose irregular patches of ochre and brown to situate the major shapes of the vegetation.

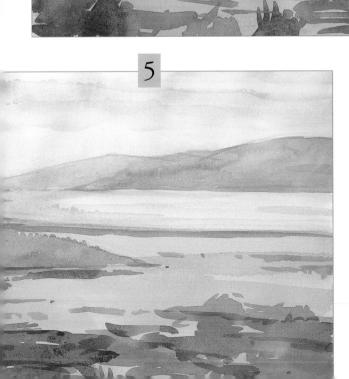

The water of the lake acts like a mirror, so it should be the same color as the sky. To emphasize the edges of the banks, go over them with a medium hue of violet.

Before adding a new layer of color, make sure to allow the previous washes to dry completely. To prepare the color base in the foreground, add to the green of the land broad, horizontal brushstrokes in a slightly broken green with a bit of raw umber.

Finish sketching the effect of the grass using small brushstrokes that mix green, burnt umber, and a little raw sienna. The latter color is used to add more intensity to the vegetation in the middle ground.

As the brush moves downward on the surface of the paper, it should be less dilute and carry more paint in order to create the ultimate appearance of depth. In other words, the most subdued colors appear to be at the greatest distances.

The resulting contrast heightens the definition of the vegetation in the foreground. Use irregular brushstrokes in sepia to recreate the texture of the foliage, leaving small openings through which the underlying color can breathe. The greater the contrast in the foreground, the greater the effect of distance created by the faded planes in the background.

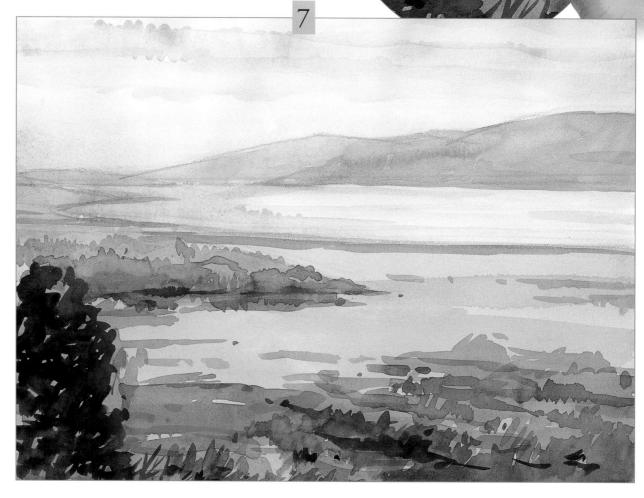

6

EXERCISES

USING the COULISSE EFFECT

The *coulisse* effect involves working with clearly differentiated bands of color. It is, in comparison to other, more complex methods—such as painting the intervening atmosphere and projecting lines of perspective—a simple effect that allows us to give depth to a landscape. Despite its simplicity, there are several considerations that beginners should keep in mind, which are presented below.

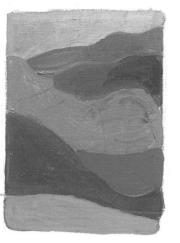

The coulisse effect is a very simple way to suggest depth by superimposing strips of flat color. The order of the colors is very important: Warm color dominate in the near planes, and cold colors in the distant ones. The distribution of colors should constitute a tonal scale.

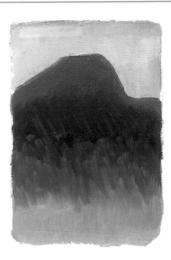

By blending the different strips of color to form a gradation, you can highlight the effect of depth; however, the distinction between planes seen in the previous example is replaced with a more subtle representation.

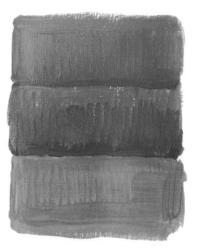

To represent different planes in a landscape, the planes must be clearly differentiated through color changes. If you paint in a naturalist manner, these changes of shade should exhibit minimal contrast.

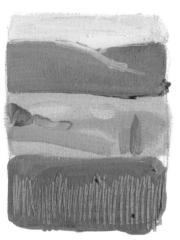

Every plane in the landscape needs a different degree of resolution. The foreground can be depicted with greater contrasts and offer textures, details, and sgraffito. In the middle ground, the treatment is less detailed, and in the distance everything is reduced to broad, monochrome patches of color.

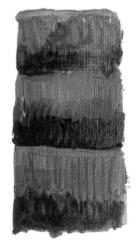

To superimpose planes in the same color, you can use false contrast to differentiate between them; that is, you can add a darker green as a gradation so that each band of color can be distinguished.

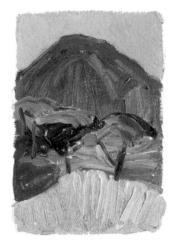

When the various planes are clearly differentiated by color, you can introduce expressive effects, such as impasto brushstrokes or striations in the foreground and background. These brushstrokes must always follow the direction of the surface represented. EFFECTS

NOTEBOOK

ASUNNY

A SUNNY Scope Landscape

If you want a landscape to appear sunny, you must exaggerate the contrasts between the lighted and shaded areas; the darker the shadow appears, the brighter the direct sunlight that bathes the landscape will appear. In addition to setting up contrasts of intensity, you must also create contrasts of scale; warm colors must be present in the sunny area of the landscape and cold colors in the shadows. It is important to use pure, saturated colors, which are more expressive.

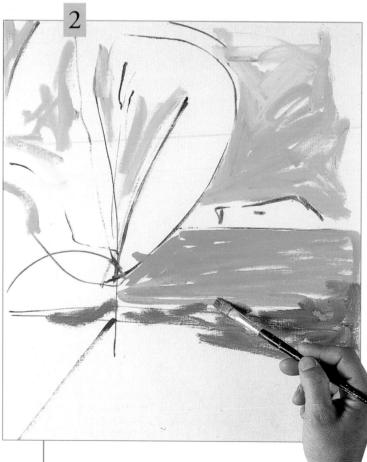

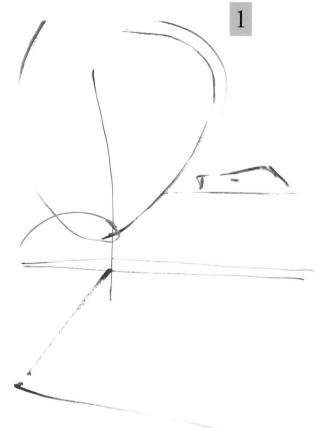

The sketch is done without a preliminary drawing by tracing directly on the canvas with the tip of the brush. This will help you understand the composition and the main lines of the landscape. The sketch also identifies the location of the tree, the house, and the edges of the sunny area in the foreground.

First paint the sky and the sunny field with yellow and orange, filling in the color of the whole area, which will act as a background for the dark branches of the backlit tree.

EXERCISES

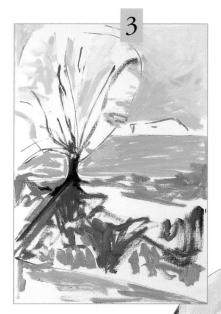

The first major contrast is created by coloring the tree and the shaded ground with a dark violet. The first brushstrokes are random and energetic, intended for expressiveness rather than to convey details of shape.

The tree's dark outline stands out in contrast to the background covered in yellow shades. The trunk is done in very dark brushstrokes, the branches in slightly drier lines.

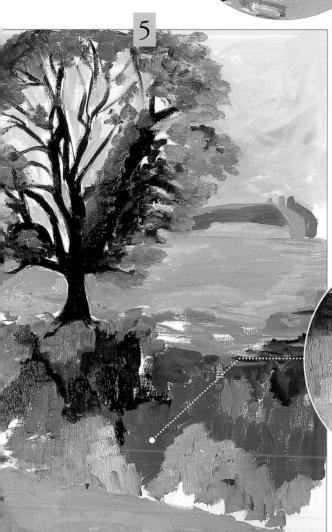

Use a fine, rounded brush to outline the tree branches in gray, violet, and black. This involves extending secondary branches from the main branches already defined.

4

Once the branches and the extensions have been painted, paint the leaves of the tree by mixing an olive green with ochre. This step is especially tricky because there is a danger of using too much impasto in the crown of the tree; it is important to paint the leaves with energy, but also with restraint.

As you progress, add variations of violet to the dark ditch in the foreground. Adding shades of violet to the shadows on the ground sets up a relationship of complementary colors; that is, colors that offer the greatest possible contrast with the oranges and yellows that are present in the sunny areas.

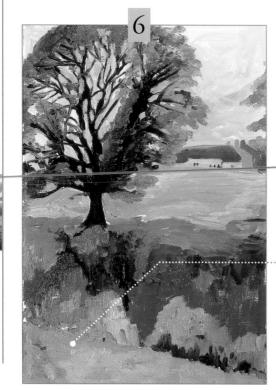

Using yellow mixed with a little white, carefully paint the pieces of sky that appear among the tree branches. Add new, softened greens in the middle plane. Finish the shaded area of the ditch with new brushstrokes in violet.

Cover the foreground with thick, dense paint. Create contrast between the sunny and shaded areas by using colors of different temperatures.

Finally, add more definition to the house in the background and some small brushstrokes in red that increase the temperature of the sunny area. A few strokes in violet contribute texture to the tree trunk.

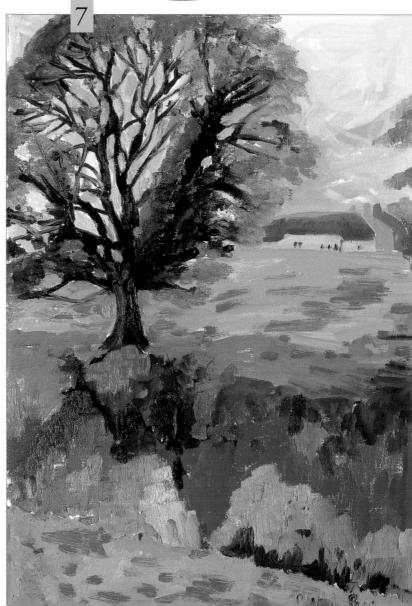

Tip

The intention of the brushstroke is very important. Consider how the colors create an impasto on the canvas as they are applied over one another.

EXERCISES

PRACTICAL

LANDSCAPE SKETCHES: A TESTING GROUND

A landscape sketch is a good way to become familiar with the various features that make up a subject. Sketching is an opportunity to note passing observations and express yourself spontaneously, using just a few brushstrokes to complete a composition in a certain range of colors or trying out a new way to apply the paint. Practicing these sketches will help you develop many skills of painting: changing the viewpoint, painting at different hours of the day, trying out new materials, and modifying colors.

A sketch doesn't require a high degree of precision. This one was done in barely thirty seconds. A minimalist application of color indicates the different planes that make up the landscape.

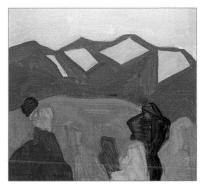

If you don't have much experience in mixing colors, you can do a sketch using flat blocks of color in shapes of just one shade.

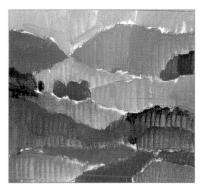

To do a good sketch, you only need to be consistent in selecting the colors and locate every plane appropriately. To achieve a feeling of spontaneity and expressiveness, you can highlight the lines and emphasize the presence of brushstrokes.

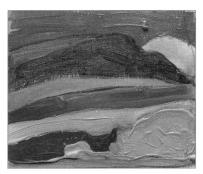

Sketching is perfect for trying out all the effects and techniques that you don't dare to apply on a larger canvas for fear of spoiling the work. It is a good way to practice with impastos and gradations.

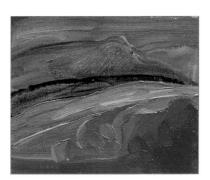

By intentionally varying the selection and arrangement of the colors, you can modify the effect of depth and the expressiveness of the sketch. Here, the river painted in yellow becomes the center of interest in the painting; in the previous example, though, the river is scarcely noticeable and blends in with the landscape.

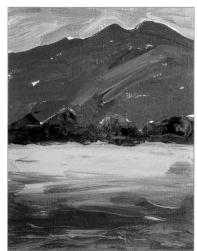

Sketches are a testing ground for trying out ways of harmonizing the features of a landscape, especially in treatments that emphasize color.

EFFECTS

WINTER Landscapes

After an abundant snowfall, the color of the grass and the vegetation is replaced by a whitish surface that acts as a light reflector. This complicates the visual interpretation of the landscape, which is flooded with cold colors. To help you learn to paint a snowy scene, this exercise shows that snow should not be painted only in white. Behind its surface beauty and brilliance are a multitude of values and tones that aid in explaining the underlying terrain more effectively. The exercise uses both acrylics and oils.

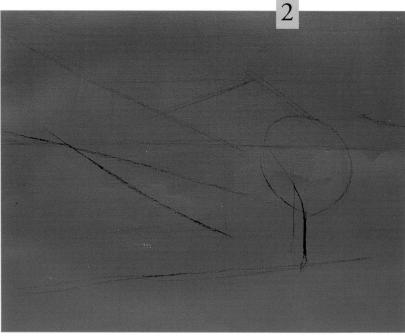

Once the layer of acrylic is completely dry, use a stick of charcoal to lay out the subject by marking a few straight lines that locate the various planes in a very general way.

Note that acrylic plays only a minor role in this work. You will use it for prepainting in a medium violet, over which you will subsequently paint with oils.

Tip

The color of the sky is very important in a snowy landscape because the light it projects directly affects the tone of the snow.

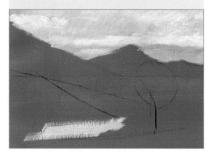

Using the same brush and a little white mixed with violet and yellow, cover the broadest areas of the landscape. Apply the color of the snow in the form of spots using the dry brush technique, with gradations around the edges, leaving spaces for the violet in the background to breathe.

Add the trees in the background using very impressionistic brushstrokes in brown. Think of the vegetation as mere patches and avoid adding textures and details.

The state of the s

Apply the color to the sky using a medium flat brush, working with thick paint only slightly diluted with turpentine.

4

Add the snow in the foreground using well-spaced brushstrokes that reveal the violet in the background. Violet represents the shadows and helps define the irregularities in the terrain. Apply some new patches in brown in the distant planes.

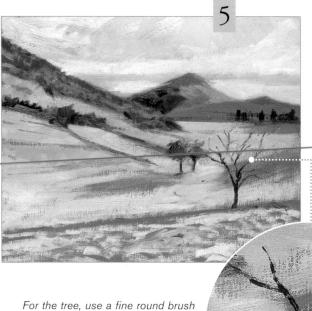

Create the vegetation on the mountains using different shades of brown. Moving downward through the painting, paint the two trees in the middle ground as two spots, with slight gradations that represent the crowns and darker lines for the trunks.

Tip

A fine round brush is very useful for adding the final, definitive touches to the vegetation. The background remains impressionistic, with no touching up or texture.

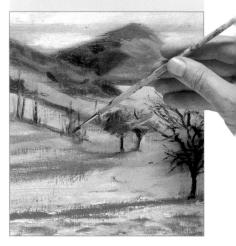

For the tree, use a fine round brush loaded with burnt umber to draw the vertical line of the trunk and the direction of the branches. Trees and bushes stand out in clearer profile in a snowy landscape, and they are rendered in darker colors.

Conclude by adding brushstrokes of ochre over the previous color to create the effect of light on the branches. Use the same brush to paint dark lines in the vegetation in the center of the painting and new variations of white (yellowish and bluish) on the snowy ground at the bottom.

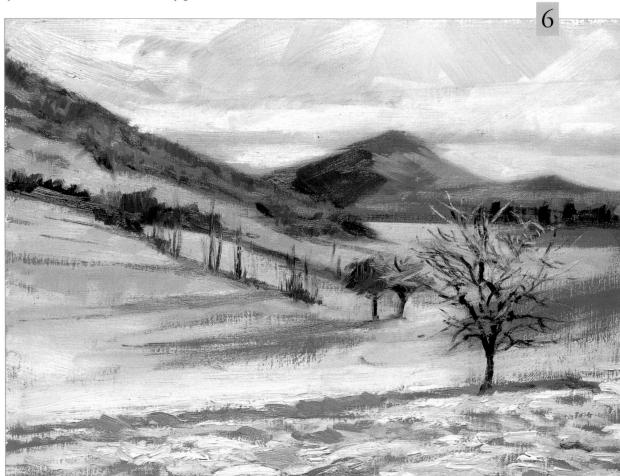

The COLOR of SNOW

You should not think of snow as a homogeneous white mass that neutralizes the colors of the landscape, like a cloak that covers everything. In fact, a scene dominated by white can be translated into violets, ochres, blues, and oranges. In the same fashion, it is important to make the most of brushstrokes and other effects to adequately depict the consistency and surface of snow.

You can use small, juxtaposed brushstrokes that allow the brown of the background to show through tentatively. The brushstrokes need not be white; variations are obtained by mixing white with a little yellow or blue.

In painting snow, it is appropriate to work over a bluish, violet, or brown background. Notice the texture of snow created by passing a palette knife loaded with white over the blue color field.

When working with washes instead of impastos, it is very effective to use the dry brush technique to represent snow-that is, using a stiff brush with scarcely diluted paint that covers thinly.

Shadows on the snow are painted in blues or violets. This sample shows snowy, undulating terrain done by blending (left) and with brushstrokes (right).

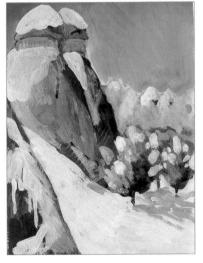

In a snowy landscape, it is not enough to cover certain parts in white. White should be used only when the sun illuminates the scene in a very direct way. You must learn to see shades of color where there appear to be none. Compare this image to the following one.

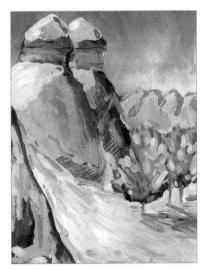

When the sun is lower on the horizon it casts more shadows on the snow cover. Thus, the landscape offers a greater richness of tone; the whites are transformed to pinks, blues, and reds.

EFFECTS

MATTER

LANDSCAPE and MATTER Painting

A natural landscape is one of the best subjects for matter painting, a technique that involves using dense impastos. Oils mixed with the palette knife are a very common medium.

In addition to mixing colors on the palette, palette knives are commonly used to apply the paint directly onto the canvas; they take the place of the brush and provide a new range of effects. This exercise combines these practical resources, introducing you to impastos applied with a palette knife and finished up with a brush.

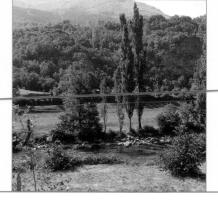

Tip

Before drawing the trees, it is important to define the planes clearly. They are indicated with a series of horizontal or diagonal lines that divide the landscape into the various distances.

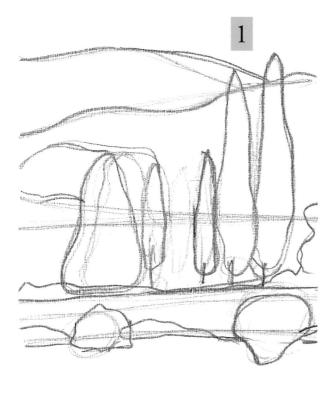

Before beginning to paint, it is advisable to sketch the main shapes. This drawing is synthetic, comprised of a few wavy lines that distinguish the planes and define the most important plant shapes.

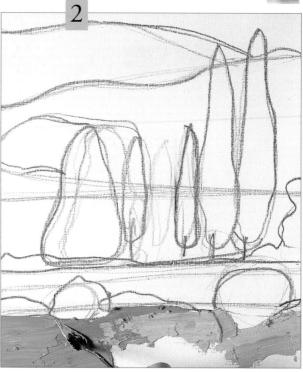

Set to work on the lower part of the picture. Cover the foreground with dense paint, a mixture of ochre, yellow, white, and a touch of burnt umber. Work with the palette knife held flat to create clear differences of tone and value.

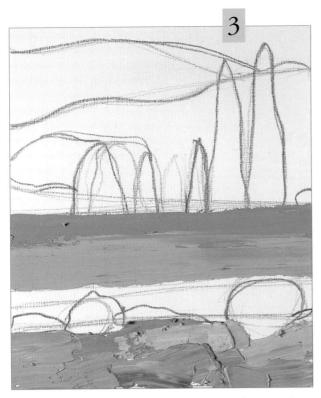

In the lower part add greenish ochre and raw sienna to give greater variety to the overall tone. Use the flat base of the blade to produce the smooth surface of the grass field in the middle ground; it is done in two tones of green that are spread out horizontally.

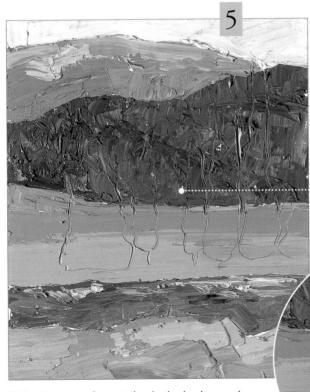

Paint the mass of vegetation in the background, enriching the greens with shades of orange and violet. The most distant mountains and the sky are also done with the palette knife, with more white added in the final mixture.

Tip

Applying the impastos onto the original drawing covers up the shapes and the outlines of the vegetation. You can restore them by drawing with the point of the palette knife onto the layer of fresh paint.

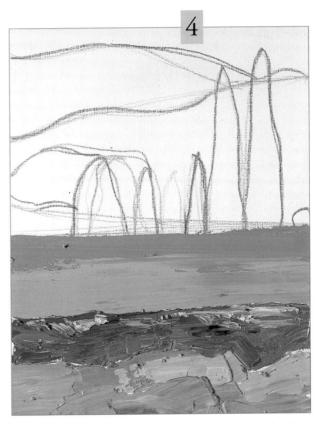

Paint the brook with the palette knife, mixing ultramarine blue and cobalt blue. The points of light on the water are pinpoint additions of white, using just the point of the palette knife to deposit the right amount of color.

To represent the texture of the vegetation, manipulate the palette knife in an agitated, random pattern, in keeping with the irregular surface of the area being treated.

There's no reason to limit the use of the palette knife on the painting to what you can do with the blade; it can be combined with brushstrokes. Using a medium flat brush, heighten the contrast along the banks of the river by adding patches of violet and a preliminary rendition of the vegetation.

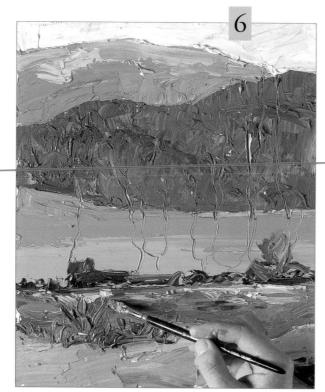

Tip

When working with paint and brush over an impasto, avoid making several passes. Otherwise the new color will mix too much with the underlying one.

Add small details to the vegetation in the lower part of the painting with the point of the palette knife, and work on the crowns of the trees in the middle ground. Use the palette knife to work the impasto in the direction the leaves grow to create a realistic texture.

In the illuminated area of the tree, apply an impasto in light green and ochre; on the other side, apply darker greens mixed with a little violet.

Use the point of the palette knife on the surface of the impasto to create sgraffiti, textured lines that contribute to the effect of the grass.

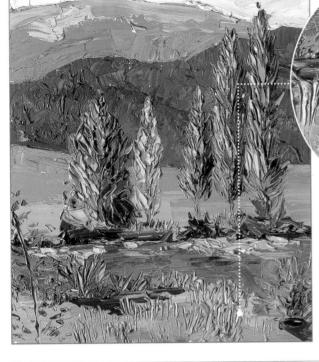

8

Once the trees in the middle distance are done, return once again to the foreground and add new impastos to the previous ones. Use the brush to paint the shadows of the bushes and the leaves on the stem at the left. Sgraffiti applied with the point of the palette knife produces the branches.

C

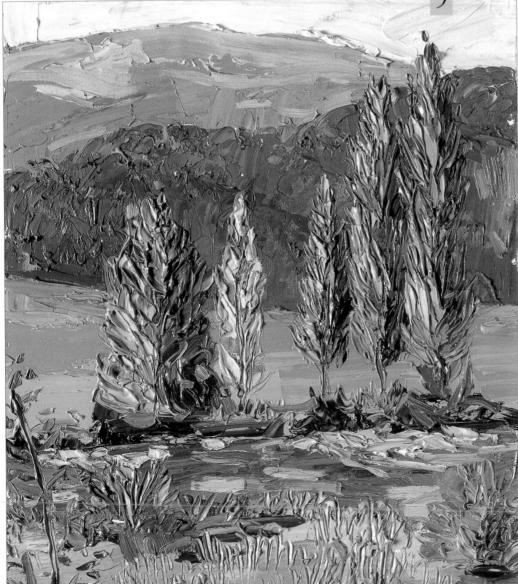

Apply the final touches with the brush. Paint a few contrasting brushstrokes on the distant mountains and thicker impastos on the surface of the water to give it more energy. Now let's see how the preceding exercise, done by a professional artist, was completed by art students. Although the students did not paint the same model as the professional, they successfully created texture in their chosen landscapes. Their various techniques and uses of color are worth commenting on. Learning from the work of these students should motivate you and help you progress in your work.

STUDENT Work

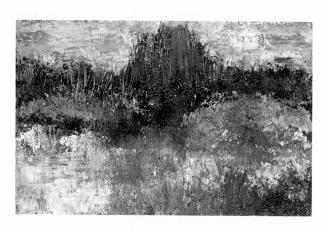

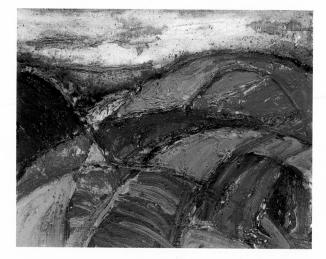

Thick, striated lines in impasto define the shape of the fields and the hills. These same textured brushstrokes break up the uniformity of the sky. An oil impasto covers every plot of land in color and gives the painting a vigorous appearance. The colors were not mixed on the palette, but rather on the canvas, and the brushstrokes are visible. The result is a very lively painting. Painting by Gisele Messing.

With exuberant vegetation, it is preferable to work in broad areas of color that give the painting an abstract appearance. Differentiation among planes is achieved through strong contrasts involving bright colors. It is not necessary to paint the vegetation in green; you can use any color on the palette. Textural effects are produced by thickening the paint with marble dust and applying brushstrokes in impasto in the upper part of the painting. Painting by Pilar Piquer.

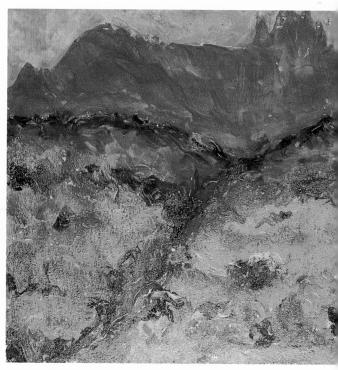

When working in two clearly differentiated planes, it is appropriate to emphasize them using bold color contrasts and different brushstrokes. Thus, the outline of the mountain farthest away from the observer is done using brushstrokes of a diluted reddish sienna and violet, creating a homogeneous surface devoid of texture. In the foreground, on the other hand, the brushstrokes take on more intensity and body, and warm colors such as red, orange, and especially yellow are more prominent. Painting by Teresa Galceran.

To create the granular or mottled texture of the field, the painting was first covered with a paste of gesso. Once this dries, it offers a surface that shows the brushstrokes, but it is not as abrasive as marble dust. The sections of the prepared surface are painted with bright, contrasting colors, alternating strips of warm and cold tones. Painting by Elvira Balague.

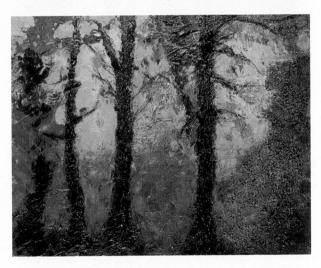

This section of woods was painted on a surface prepared with several irregular additions of marble dust. The texture makes the bark of the tree trunks more realistic, and a few brushstrokes in impasto do the same for the branches. The background of the composition is bathed in warm, light colors that make the trees stand out in greater profile through the effect of backlighting. Painting by Maria Gonzalez.

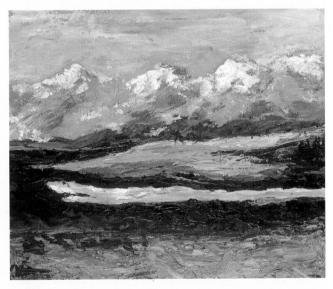

Additives such as marble dust and gesso are not always needed to create textured landscapes. Sometimes all it takes is applying lots of color with the palette knife. The lower part of the painting was done by mixing the color right on the canvas with small strokes that imitate the relief in the terrain. Applying paint with the palette knife permits a very effective and expressive treatment. Painting by Teresa Pijuan.

The Forest Floor: EFFECTS *of* LIGHT

The forest floor is rich in shades, irregularities, fallen leaves, and sparkles of light that penetrate the leaves of the trees. The appeal of this composition stems from the translucence of the leaves (how they are illuminated by the light that passes through them) and from the patches of light projected onto the soil. You will paint the subject using acrylics.

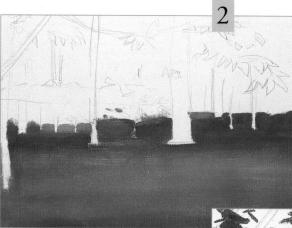

First do a pencil sketch. There is not much spatial depth in the model, which forces you to focus on the shape of the tree trunks and their location, leaving quite a lot of space for the forest floor. There is no need to draw the leaves; you only need to suggest a few of them.

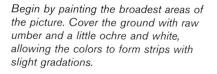

The next step is to color in the darkest areas of the leaves on the trees with a green that contains slight bluish and brown variations. Also paint the tree trunks using burnt umber and a dab of violet.

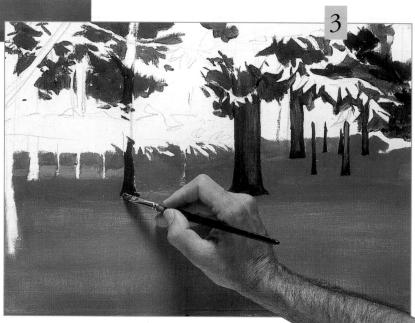

EXERCISES

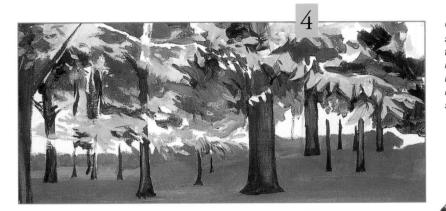

Over the dark patches of leaves, apply spots of a yellowish green to signify the leaves illuminated by sunlight in the foreground. Since these leaves are closer to the viewer, it is appropriate to define their shape a little more.

Finish coloring in the background spaces that are still white using bluish spots (ultramarine blue and white). Darken the background of the woods by superimposing dark brown brushstrokes on the existing reddish forest floor.

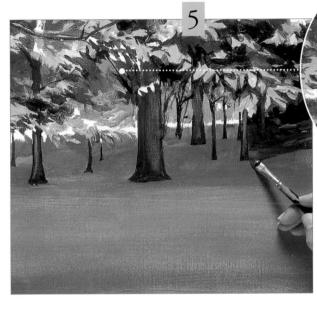

The leaves should be represented as spots that overlap one another in imprecise shapes and blend together. As a result, we never see the complete shape of a single leaf, but rather a wonderful, curious confusion. However, the direction of growth of the foliage is well defined.

The last additions of color give the painting its overall effect. Apply a very light ochre onto the forest floor to create the effects of light on the ground. Working rapidly in a horizontal direction with a fairly dry, flat brush gives these patches an open, impressionist appearance.

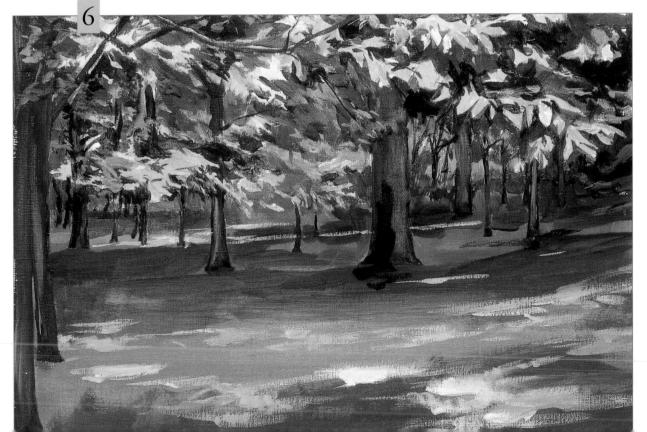

ALEXANDER COZENS (1717–1786)

Alexander Cozens

A famous British watercolorist of the eighteenth century, Cozens advocated abstraction as the basis of his compositions, using blots of color as an organizing system for landscape and a stimulant for the imagination.

In his book A New Method of Assisting the Invention in Drawing Original Compositions of Landscape (London, 1785), Cozens supported the "blot" method, which involves the use of more or less accidental spots to suggest landscape: "The senses are confronted with clusters of lighter, darker, and different-colored blotches, and not with a finished shape like the ones in classical art produced through perspective, proportions, and drawing."

His system was intended as a deliberate challenge to the traditional ways of painting landscape, and it arose as a new antiacademic movement to capture landscape in a more subjective way. Cozens wrote, "I regretted the lack of a sufficiently expeditious mechanical method ... for extracting ideas from an ingenious mind talented in the art of drawing."

The artist advised against the traditional method of drawing in minute detail; he preferred a quick, disorderly sketch to suggest new possibilities: "There can be no doubt that too much time is wasted in copying the works of others, which tends to weaken

Alexander Cozens. Mountain Peaks, 1785. Sepia ink, 8.5 × 12 inches (22 × 30 cm). British Museum (London).

Alexander Cozens. A Villa Next to a Lake, approx. 1770. Pencil and sepia and black inks, 6 × 7.5 inches (15 × 19 cm). Private collection (London).

the faculty of invention; I have no hesitation in asserting that too much time is perhaps wasted in copying landscapes from nature itself." According to Cozens, there is a part of the artist's creative process that is beyond control. He believed that perception of the landscape originates in basic shapes, and his theory emphasizes randomness and the artist's capacity for synthesis: "Sketching . . . involves transferring ideas from the mind onto the paper . . . ; coloring involves producing varied markings . . . by creating random forms . . . , from which ideas are presented to the mind Sketching is delineating ideas; spots of color suggest them."

Cozens imparted his knowledge to his followers at Eton College in London, instructing them to use blots to discover ways to paint landscapes. Then, a little retouching was all it took to transform those colors into a legible landscape sketch. Although blots of color stimulate invention, they must be further refined with details to produce a painting. Cozens wrote: "The sensory datum is common to all, but the artist elaborates on it and clarifies it with his individual mental and manual technique, and thus leads society to a greater experience and performs an educational purpose." It really mattered little to Cozens if the initial shape of the landscape was premeditated or improvised. What counted was what the artist chose to do with that shape.

Alexander Cozens. Mountainous Landscape with a Hollow, 1785. Watercolor and ink, 9×12 inches (23×30 cm). National Gallery of Art (Washington, DC).

Harris County Public Library Houston, Texas